CONNECTING

CONNECTING

The Art of
Beth Ames Swartz

by Mary Carroll Nelson
Introduction by Harry Rand

NORTHLAND PRESS ✿ FLAGSTAFF, ARIZONA

For Melvin, Julianne, and Jonathan Swartz

The cooperation of the following institutions, and their permission to reproduce art held in their collections, is gratefully acknowledged by the publishers: Arizona State University Art Collections, p. 37; Beaumont Art Museum, p. 95; Herbert F. Johnson Museum of Art, Cornell University, p. 87; Jewish Museum, p. 64; National Museum of American Art, Smithsonian Institution, p. 75; Phoenix Art Museum, p. 82; and the San Francisco Museum of Modern Art, p. 98.

The majority of the art photography included in this volume was done by Peter Bloomer/Horizons West. Notable exceptions are Leo Karr, p. 111; Paul Loven, p. 115; Herb Lutz, p. 104; and Lou Russo, p. 37.

CHOICE

Sometimes it walks with me like an enemy;
Imprisoning me . . .
Keeping me from rest . . .
Intruding into my consciousness . . .
Sitting with me like a judge.

When I have worked and worked feverishly
Shutting out everything but the painting
I eventually come to a pause . . .

Then I think . . . are you crazy?
Spending your life in a room making art

Or traveling half-way around the world to
 pursue an idea for your art?
Are you really making a contribution or
 is it merely self-indulgence?

Then I ask myself . . .
Is there anything else I would rather do with my time . . .
Over the long haul?
Usually the answer is no.

BETH AMES SWARTZ
June 1976

ACKNOWLEDGMENTS

I would like to express my appreciation to Linda Andrews, publisher; Steven L. Mitchell, editor; and Susan McDonald, associate editor, for their dedicated efforts on behalf of this book. My gratitude is also given to Marlene Schiller, for her help and friendship; to my husband, Edwin B. Nelson, for his sustaining compassion and patience; to our daughter, Patricia Nelson-Parker, whose insights and caring are treasured; to Beth Ames Swartz for her gifts of talent; and to Mary Lou Reed and Harry Rand for their contributions to *Connecting*.

MARY CARROLL NELSON
Albuquerque, New Mexico
January 1984

CONTENTS

INTRODUCTION

Beth Ames Swartz worked at an approximately fixed artistic agenda for twenty years, until in the late 1970s, she veered away from the then-prevailing lyrical abstractionists. Her reaction was violent and effective. Fire became her natural ally. The flames burnt away past assumptions and conceptions, and in the process, Phoenix-like, her new work emerged. The size of the pieces increased as she mastered larger forms and extended her control of the compositions dictated by the process of incineration and restitution. She broadened the range of her colors as she secured and refined the ability to monitor papers interred in earths she collected in her travels. Swartz's works became layered when she added ply after ply to enrich the surfaces and to build up igneous forms. Texture assumed an independent identity. The character of tactile interest no longer resulted solely from the track of the pigment's application, but was a protagonist equal in force to color, scale, and the pattern of composition. These new, pyrogenic pieces were the willful result of a campaign whose purposiveness brought Beth Ames Swartz to the threshold of new vistas.

Within the compass of Swartz's production of the late 1970s and early 1980s, strongly antagonistic positions are sustained in proximity. These isometric oppositions intensify one another. Genuinely unexpected qualities are thus maintained despite apparently disqualifying characteristics.

Destruction by fire, and regeneration of the restored surfaces, represent processes that act as surrogates for *analysis* and *synthesis*. In this context, Swartz's initial violence to the work features a technique in the artist's inventory with strongly therapeutic implications. To a great extent, her invitation to cathartic violence occasions the physical character and the psychological space of these works. Swartz's destruction of materials was neither accented nor utterly camouflaged in the finished pieces. Thus the lurching, imperfect heroism of human renewal after defeat became an overt part of the subject matter of these works. Yet artists have used physical destruction long before Swartz, although none precisely in this manner. The Medea-like treatment of her materials presaged a violence that, in her more recent works, is iconographic; form became subject matter.

Pure destruction need not, after all, be the harbinger of disaster, or even of pessimism, as Tinguely has shown. Swartz's pyrotechnics were certainly preceded by the "Group Zero" artists, Otto Piene and Hans Hacke, whose work invoked by symbol and involved by example the environment and natural forces—of which fire was prominently featured. Yves Klein's use of fire was far more classical, as in his *Fire Fountain* that celebrated fire's light rather than its destructive capability. Several artists have practiced drawing with smoke, and many employed fire, ice, and natural decay to produce images as part of process-art. Swartz, more vividly than many others, incorporated fire into her pieces both as formal means and symbolic component. She did not present this element of the work didactically; in the fire pieces, the scarring and soot of the flames never remained intact or unchanged. Swartz assumed that conflagration would leave an inimitable mark, distinct as any artist's touch or style. Fire was thereby made a collaborator in the work and a protagonist in the subject matter; Swartz's subsequent alterations furthered the affect of the painting rather than cosmetizing the destruction. In sum, her techniques tended toward the individualized and intimate, although shrouded in the

finished work, where the separate formal elements are artfully mingled and visually difficult to untangle.

Swartz is far too humanistic to employ any technique except for what it can convey of psychology. Experiences beyond the picture have the uppermost claim on her allegiances. She seems absorbed by the extra-pictorial, by psychology rather than by records of phenomena. The interior of her works are rarely muffled in darkness to suggest some false profundity. Swartz's palette is the inheritor, at long remove, of the Impressionists. Her latest work recapitulates the evolution of the divided stroke from Delacroix through Monet, Van Gogh, and post-Impressionism. Her brushwork is freer than ever. Swartz's color schemes, already vivid in the late 1970s, have become animated with swirling divided touches of saturated hue. The unlikely legacy of the nineteenth century is revealed in her penchant for a patterned surface that rolls across her work. In earlier pieces, this sense of a surface in front of the picture—proxy for the landscape peels that were the hallmark of Cézanne—was not as animated as it has become in the newer, agitated, and eddying forms. These rotate and spin, flow and churn with all the manic vigor of Van Gogh's *Starry Night,* and it is that agitation, rather than any passing fashion of philosophic underpinning, that is the greatest appeal of these works. The distinctive color that set apart her burned paintings/collages derived from the metallic pigments and literal earth colors (dirt) Swartz employed. This palette remains her most characteristic trait. In their lineal descent from the obvious parentage of the Modernist tradition of Monet, Braque, and Picasso, Swartz's collaged works can be seen as a special case of late Cubism, with close affinities to Lipchitz's shallow relief panels. Nevertheless, despite clear formal ancestry, Swartz's special use of materials is hers alone, the product of long experiment.

Founded on historical precedent, Swartz proceeds from authentic urgings and terms of analysis she has assumed and in which she enrobes

her personality. The artist she has become is informed by such considerations. If the unfolding personality travels a different course from the development of art in an artist's life, then both may be distinctly present in her work, and each maintains a driving and directive force propelling her stylistic evolution. Her sense of the invoked past, both the recent and distant (even primordial past), is held in common with the New York School. The non-discoursive and expressive imagery she so conjures nevertheless diverges fundamentally from that of the generation of the Abstract Expressionists. The earlier artists tapped general mythology, while Swartz's contemplation is more focused with different goals. That her work does not resemble Abstract Expressionism does not eliminate those artists as a supporting sanction for her enterprise; her personal iconographic program shares assumptions with those painters. What differs radically is her channel of approach to psychology and moral tone. The earlier artists found their way into their images and autobiographical feelings by means of Freudian, Jungian, or mythical concepts; the good they expected to do was indirectly social, through art history. The recent expression of individual character emphasizing personality formation records the imprint of a single disengaged impression of the world. The enterprise of psychology as the initiator of art springs centrally from the Surrealists who were themselves great trailblazers for the Abstract Expressionists.

This reuniting of the Modernist and Surrealist traditions is a program that Swartz subsumes. Combining these two sources of invention, Swartz traverses ground originally won by the Abstract Expressionists. Swartz attempts to reconcile the major considerations of the period during which she developed, and to react to prevailing practices. She has struggled with passing artistic novelty and fashion, even while the intellectual poles by which she reckons have shifted with current trends. Whatever provisional address her works make toward the world, Swartz solicits from the viewer suggestions that recall the order of nature and associations of natural

forces. The sense of natural order possessing an harmonic rule and under-
lying cadence, we call Classicism; associations of the effects of natural
forces, their magnitude and power, we call Romanticism. Accounting for
both, a balance is struck in Swartz's work. Despite the supportive assump-
tions that help to generate these works, as well as the historical context
within which they operate, each of Swartz's pieces represents an outpour-
ing of energy, of verve, so direct, so personal and idiosyncratic that while
offering ample beauty for the spectator's pleasure, the very notion of
sophistication comes into question. Nothing seems to have been held in
reserve in this torrent of intimacy, and in almost every sense that is cur-
rently fashionable, this is not what is meant by sophistication: suave and
subtle color relationships distantly managed without engagement, glanc-
ing citations of art history, technical means that coherently summarize and
advance the gains made in postwar art. At first acquaintance, none of this
seems to be the freight of Beth Ames Swartz's work. Instead, something
altogether as potent faces the viewer unexpectedly. The spectator's best
preparation would suppose of knowledge of recent European and Ameri-
can art, and the most receptive viewers would undoubtedly be possessed
of a resilient spirit as well as a broad literary background, Kabbalistic
learning, and a Talmudic turn of mind, for an urge toward flux and dialec-
tic lies at the heart of her work.

HARRY RAND

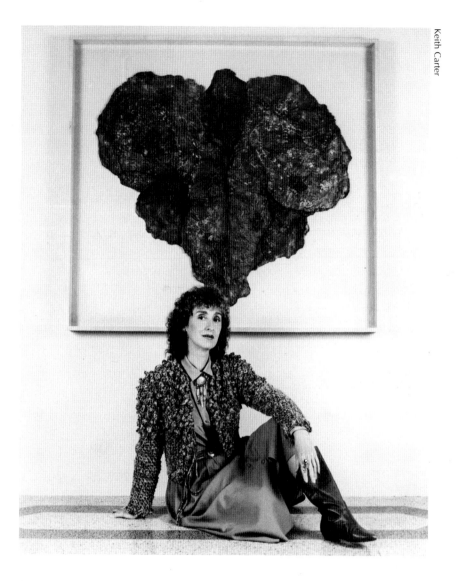

6

CONNECTING

*Connected. Everything is connected and I cannot see the end of it. I cannot
see the beginning of it. Yet, the saying itself that there is no end and no
beginning is already the measuring it with its own measure of a beginning
and an end. Reality is this. Mystery is this.*

LEO BRONSTEIN

Beth Ames Swartz is a visionary artist whose life and work have
undergone clearly marked transformations since 1959 when she
moved from her native New York City to Phoenix, Arizona. The
desert threatened her then as a harsh, unrelenting place; yet, with
time, the beauty of the Arizona landscape touched her and enabled her to
connect not only with the desert but also with the natural world. This
linkage from the experienced environment to her inner landscape inspired
a spiraling series of aesthetic breakthroughs, leading to ever-evolving
work that has been widely exhibited since 1974. Today, she is well known
as a creative artist. Propelled by a driving urgency, she has repeatedly
produced innovative art in series based on themes related to a contempo-
rary search for meaning. By working in series, she has explored many
aesthetic themes over an extended period of time in a way she feels is
similar to scientific research.

In person, Swartz is an active, accessible woman: taller than average,
finely tuned, slender and attractive, she draws people into her orbit with
an open manner. She speaks quickly and uses her hands in generous
gestures as she talks; she is frequently called upon to lecture. Even as a
young art teacher, she lectured on creativity. The result is a poised person
whose talks are punctuated with humor. Though intensely serious and

dedicated to her art, Swartz jokes, often at her own expense, in a twangy New York accent. She can be thoroughly entertaining.

Swartz actively seeks experiences, people, and ideas, both philosophical and aesthetic. As an innovative artist, she is unique not for her raw material, but for what she creates from it. Her distinction lies in the chain of connections she makes between disparate dimensions. To see a correspondence where others do not is to be set apart from the crowd. Swartz, gifted with insight, responds to numinous experiences with strong symbolic art marked by her mystic nature and intellectual rigor.

Her childhood was spent in an intellectually supportive family, yet the artist suffered inwardly from a sense of being fundamentally different in some way from her relatives. Without realizing it, she yearned for a sacred center. At Cornell she met a gifted teacher of art education, Frances Wilson Schwartz. Schwartz inspired the young student with a desire to teach art as a way to encourage mental health. She believed in Beth Ames's creative ability and introduced her to an appreciation for the spiritual. This relationship of student to mentor had an enduring effect.

Beth Ames Swartz is committed to a spiritual search. It has led her to study theories of creativity, psychology, and Zen. In her late thirties, on a trip to Israel, she discovered for the first time a vital connection with Judaism, particularly with the mystic heritage of the Kaballah. In the Kabbalist tradition, Shekhinah is the feminine aspect of God who balances God's masculine qualities. The Shekhinah appeals to Swartz; the concept suggests an androgynous source of the universe. It relates to the Eastern yin-yang unity of opposites. In her work and in her thought, Swartz attempts to unify opposites. Disorder and order are the polarities she attempts to fuse. As she has matured, she has focused ever more intently on balancing her spiritual and aesthetic goals.

The social landscape of the past two decades has presented all women with new possibilities, and Beth Ames Swartz has emerged from these

years transformed into an assured artist, a model for those seeking to know themselves in terms of a shared culture, a shared planet—even a shared universe. Her mind ranges broadly, establishing and rethinking diverse concepts from the fields of religion, earth sciences, contemporary sociology, literature, and philosophy. Her social awareness is based on contacts with others; her quest for knowledge takes her to distant conferences and workshops related to art, creativity, women's art, self-healing, and human potential. She is a voracious reader. Years after reading a passage, she not only recollects it, but can also find it in her own library. Books she has read remain in her thoughts as segments of her encompassing world view. The quotations she finds significant are affirmative testaments to possibility. Her memory is laced with names of the people who have affected her life. She has connected with many pivotal thinkers whose insights influence our era. This chronicle, therefore, is a multidimensional tapestry of ideas, biography, and aesthetics.

As a self-aware artist intent upon connecting with the depths of her talent, Swartz is also conscious of her role as a modern woman. The years of her creative growth correspond closely with the rising tide of the feminist movement. Since the early sixties, she has identified with the momentum of feminism toward liberation of women from stereotypes that narrow their options; however, her art has rarely addressed itself to protest. She has explored feelings of connectedness between herself as a woman and the earth with increasing intensity, but her art could not be described as "earthy" or body-oriented. Though she does not take an extreme or angry position against male dominance, she has been deeply affected by it and is a committed feminist. Were there such a word, she could also call herself a masculinist, because what she seeks is a balanced society, one in which individuals are spiritually whole. The anger in her reactions to her own life, has, for the most part, been personal and psychological. Its effect on her has definitely been a torment as well as a catalyst for her art.

Swartz's present effort to come to terms with her anger is to become balanced—whole—through self-healing. She believes that if even one person achieves this sort of balance, it adds to the health of the culture. "My art is political in the sense that it is dedicated to the healing and balancing of the earth. I am against those things which threaten to destroy humanity, socially or physically. When I deal with my art as healing, I hope it will help change inequities."

In recent literature one finds references to the role of artist as shaman, a mediator for others. Swartz has sought knowledge of shamanism and of nonmedical healing techniques in the human potential movement. The idea of being an agent through whom others gain experience is close to the original goal Swartz had as an art educator. Teaching remains an important commitment though her arena is no longer a classroom. The arena in which she produces her art, and from which she encounters the world, is her home.

Germaine Greer speaks of the confinement that women artists face because of the equivocal relationship between their giftedness and the home:

> The upper limit of women's work is as far out of sight as that of men's work. We cannot wonder that that upper region is so sparsely inhabited. It is staggering that any woman escaped into it for any time considering the obstacles in her way. . . . The primary obstacle was associated with the family . . . the family was the environment in which women lived and from which exclusively they drew their gratification.

It is even more significant that Swartz has become a mature artist within a marriage at which she has worked hard as both a wife and a mother of two children, now adolescents. She does not claim to be a

super mother or a super woman. "I'm not interested in being a perfect wife or mother. I just do the best I can," she says. Her studio is separate from but adjacent to her home. She has never had a sustained period of complete freedom from family responsibility, nor have many others who have tried to grow within a structured life—structured, but not conventional. As Swartz emphasizes: "My life is not conventional. Spending eight hours a day in a studio making art is unusual." It is not an easy life, but it is necessary to one who intends to "have it all," the growing ethos as women's roles continue to shift in contemporary society.

"All through the years it has been a struggle to take the time to work in the studio. Some years it has been easier, some harder. Some weeks, impossible, what with family emergencies, children's illnesses . . . often there was no one else to drive to the doctor with a sick child or help a friend who just lost her husband. I know I probably have painted two hundred less paintings in my lifetime because I am married, have raised two children, and run a home, but how can that be measured? More and more, I am realizing that my art, though a critical part of my life that I cannot conceive of being without, is not my entire life. Loving family and friends is also part of my life."

The discoveries Swartz has made have to do with the shared life of society, where it is headed, as well as with art, for she has accepted a holistic paradigm as proposed by futurists Alvin Toffler, Fritjov Capra, and John Naisbitt to heal the planet. Connections within and without lead her to the ancient conclusion that the microcosm reflects the macrocosm—each self, each life, is an aspect of All That Is. Gustaf Stronbert, in *The Soul of the Universe,* concisely stated such a vision of unity: "It appears then, that the universe is a unitary 'organism,' rather than a loose collection of atoms and stars." Such a thought, in its many ramifications, unifies the evolution of Beth Ames Swartz, as a woman, as an artist, and finally as a seeker of wisdom and peace.

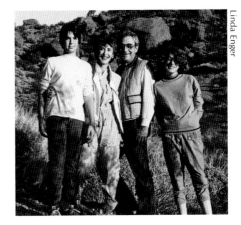

The Swartz family, October 1983, l to r, Jonathan, Beth, Melvin, and Julianne.

1963
Odd One Out
pastel on rice paper
19 x 13½ inches

BEGINNING

The expression of women's spiritual quest is integrally related to the telling of women's stories. If women's stories are not told, the depth of women's souls will not be known.

CAROL P. CHRIST

Beth Ames was born on February 5, 1936, the third child of Dorothy Andres and Maurice U. Ames. The family lived in Manhattan at 590 Fort Washington Avenue. Both parents worked in the schools; Maurice Ames was New York City Assistant Superintendent of Schools, supervising in the Bronx for a number of years before retirement, and her mother, a secretary. Beth followed a brother, Bruce (later recognized for his work as the originator of the Ames Test for carcinogens), and a sister, Sylvia. The Ameses' youngest daughter exhibited talent early, which was encouraged with drawing, painting, singing, and dancing lessons. The cycle of her growing years was steady: in the summers, she traveled and vacationed at a mountain resort with her family, and throughout the year, her aunt, Rachel Andres, taught her music and watercolor techniques.

Dancing in the hallway or making up tunes on the piano while alone in the house were ways the child gave vent to her feelings of being different. Drawing and writing poetry became her sanctuary from the conservative intellectualism of the household. Her grandparents on both sides, who emigrated from Poland and Austria, passed down their Jewish heritage, but the Ameses did not practice this religion or provide religious training for their children, and so Judaism did not play a significant role in

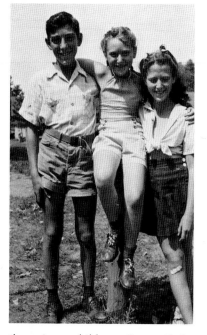

The three Ames children—Bruce, Beth, and Sylvia—at Indian Head Summer Camp, 1943.

Beth's evolving sense of identity. The talented girl responded privately to her latent, but unrecognized, need for spiritual nourishment. She remembers herself as a person whose rhythm and expression were at odds with her social milieu; she felt compelled to construct defenses against its encroachment.

"I did not feel accepted in childhood, because I was a square peg and did not fit the round holes that were the parameters in my family. From an early age, art was the only avenue I had to be myself, and I used it to survive."

An emphasis on education and achievement was part of Beth's daily environment, part of the nurturing element in her childhood. The main thrust of familial advice was toward a practical, applicable education and Beth dutifully set herself to become well educated. In love with learning for its own sake, she was accepted as a student by the distinguished High School of Music and Art in New York City; here, she was provided with two hours of daily studio art in addition to academics. In 1953, she entered Cornell University and soon met Frances Wilson Schwartz, who taught in the art education department. Frances Schwartz became her mentor and Beth was introduced to spiritual sources of understanding through creativity. Schwartz, with the prescient awareness of a gifted teacher, recognized the depth of her student's potential.

During Beth's sophomore year at Cornell, she took a class from Schwartz in which the teacher provided the motivation and the students painted in response to it. Beth recalls the experience vividly. Afterward, she was summoned into Schwartz's office, where the teacher had her work lying on a table. Beth did not know Schwartz before enrolling in her class and was somewhat apprehensive. Her concerns were quickly put to rest, though, when Schwartz praised her work and suggested that Beth was capable of making significant connections with her own interior landscape. "No one had ever noticed that in me before, and I found her assessment of this ability to be, in a sense, validating." Schwartz was also

the first person Beth had known who routinely read Kierkegaard and explored a wide range of philosophic avenues on a regular basis. Schwartz was, therefore, an important role model for the young artist.

Schwartz saw something remarkable in the young woman's art—a distinctive translation of emotional experience on paper that infused her work. She not only prophesied Beth's future, but was a causative factor in it. Frances Schwartz was an idealist, ahead of her time in seeking holistic relationships. In an essay entitled "Human Nature and Aesthetic Growth," she wrote: ". . . my experience leads me to believe that the aesthetic sense is also the moral sense, and the sense of self—of being. It seems also to be the person's imagination, taste, and integrity—his source of love and truth." Her vision had a profound influence on Beth, who served as an assistant in Schwartz's Family Art classes while still an undergraduate. Art education seemed to be a light that guided Beth's consciousness, and she decided that her future path was to lead others toward their own creativity —a contribution to their mental and spiritual growth. At the same time, she dedicated herself to becoming the best artist she could be.

After her college graduation in 1956, Beth Ames toured European museums for three months. During this tour, she was further awakened to art. At some time in an artist's development, to reach a creative level, an appreciation for composition and design must be deeply established. In effect, an illumination of aesthetic sensitivity must occur. It is possible that Beth's sojourn in Europe was encouraged by her closeness to Frances Wilson Schwartz. Schwartz had made Beth aware of her own talent and had given her a sense of mission. She was avid for a sense of connection with the great masterpieces of Europe, and she found it. Later, in Mexico, she had a similar experience with the rich art of the pre-Columbian period.

When Frances Schwartz died of cancer at thirty-nine, she left lasting proof of her confidence in Beth by bequeathing all her papers and library to her protégée. Beth had started her teaching career in the Bronx by this time, and had also begun work on her master's degree in painting, taking

Painting in Denmark, summer 1956; Beth Ames in the foreground, friend Edith Wachenheim, background.

classes at night. The evening Frances Schwartz died, Beth was attending an evening graduate class. Victor d'Amico, head of Art Education at the Museum of Modern Art, had left a message at Beth's home; she was to call him when she returned. He told her of their mutual friend's death. After hearing the sad news, she painted, in layers of gold and acrylic, an elongated, stylized portrait of Schwartz from memory. On one side, she painted a design of circular forms floating in space, dark on one side, light on the other. Later in the week, she went to Ithaca to share her grief with the Schwartz family. While there, she saw the last creative work Schwartz had completed: a mobile made of circular discs, light on one side, dark on the other. Schwartz had indicated before her death that she wanted Beth to see it. The similarity to her own work both amazed and frightened Beth; she had a sense of involvement in a vision and found it unsettling but also reassuring.

At this stage in her life, Beth was a student, a serious painter, and a public school art teacher. She preferred watercolor as a medium, a preference she retained for years, but she painted in oils and also did some experimental work. Her style was representational and figurative, with occasional attempts at abstraction or simplification.

While her professional life was developing in a variety of directions, she met Melvin Jay Swartz through a mutual friend. Thereafter, her personal life also took on a new dimension. "He took me seriously as an artist and a person, one of the few who had up to this point in my life." Early in their acquaintance, Beth gave him three of her watercolors, a series of views of the George Washington Bridge as seen from her bedroom window. One was representational, the others, less so. "You'd better live with these a while," she told him, "and take down the ones you like least." Eventually, he kept the more abstract painting. His choice signified something important to Beth: it told her that he was open to new ideas, fresh ways of looking at things. She found this very appealing.

1956
A Walk in the Forest
watercolor on paper
12 x 17 inches

The courtship and marriage of Mel Swartz and Beth Ames were predicated on the seriousness of her commitment to art: he accepted it as a given of her life. Likewise, she accepted his desire to live in the Southwest. "Mel courted me with a copy of *Arizona Highways* under his arm," she says. After their marriage on December 27, 1959, the couple moved to Phoenix with high hopes and few resources.

While her husband clerked in a law office and studied for the bar, Beth Ames Swartz again taught in the public school system, in the Phoenix suburb of Scottsdale. She created a niche for herself in the community as a lecturer on creativity. The organizational force behind an exhibition of art created by children involved in the Phoenix Parks and Recreation programs, Swartz also taught a family art class at the Jewish Community Center, patterned on those taught by Frances Wilson Schwartz, and wrote a pamphlet titled *Help Your Child Create.* On the surface, she was engaged by her new role as wife and her duties as a teacher; inwardly, however, she clung to her intention to become a first-rate painter. She developed her ability to catch a subject in transparent watercolor with lively brushwork and a minimum of detail. This reductive process echoed her own feelings and artistic inclinations; simplicity was the goal for which she was striving.

An understated watercolor, *Painted Desert* was done on location during Swartz's first year in Arizona; contours are scratched assertively and freely with a reed pen. Shadings are indicated in simple washes, overlaid with a few deft scumbles of pastel. The painting reveals a trained hand, directed by an experienced eye. The artist caught these few essentials with an Oriental simplicity and deemed them enough. Qualities that flower over and over again in Swartz's later work are already present in *Painted Desert:* a subject drawn from nature, layers of mixed media, and a tendency toward abstraction.

Here, Swartz was the observer of the desert. "It was almost like an exercise," she comments. "I was someone on the outside looking in, not

1960
Painted Desert
watercolor and pastel on rice paper
16 x 20 inches

really involved in the topography. It felt very alien to me, and I hated it. Every summer, I would go back to New York to get revitalized; then, on my return, I'd paint cityscapes from memory. Although it was sunny in Arizona, it was very depressing to me. I felt like the world was going on without me and I was missing too much. When we went out into the desert, I really resisted it. I was a city girl, born and raised."

Despite her obvious ability to paint and her acceptance by the community as a knowledgeable teacher, Swartz was still immersed in her conservative upbringing. Her command over materials and the freedom of her art had not yet infiltrated her consciousness as command over herself and freedom of choice.

Today, Swartz can look back in analytical terms: "I had moved from my father's house to my husband's house, a childlike woman seeking approval in the conventional, subservient ways I had been taught. In a way, I was like a clown wearing a mask I had learned to put on, thinking it would make me lovable. The unwritten contract of my marriage was really mutual dependency. Mel was as locked into taking care of me as I was in being taken care of."

Underlying her dependence was the desire to deepen herself as an artist, something that can best be done inwardly and alone. The resulting conflict further impinged upon her self-evaluation, causing her to fear that she was not good enough; it also fueled her search for meaning and growth.

Seeking answers to her quandary, Swartz read *The Self, Explorations in Personal Growth* by Clark E. Moustakas, in which the author discusses those who sell themselves short and realize they are doing something wrong to themselves; ultimately, Moustakas observed, this leads to self-hate. His words have a bearing on what occurred in Swartz's life: "Out of this self-punishment may come only neurosis, but there may equally well come renewed courage, righteous indignation, increased self-respect, because of thereafter doing the right thing; in a word, growth and improve-

ment can come through pain and conflict."

Swartz was strengthened by the book, which includes Frances Wilson Schwartz's essay, "Human Nature and Aesthetic Growth." It seemed related to her earliest self-knowledge under Schwartz's guidance. In lieu of a personal advisor, a book has often been a powerful substitute for Beth Ames Swartz. "It was as though my life were a research project," she says. "Because my immediate family couldn't really understand my emotional states, I explored situations or subjects similar to my own through books. It was good to find that I was not the only person who had ever felt the way I felt." It has always been a part of Swartz's conditioned response, when in doubt or confused, to search for authors and subjects that enlighten her in some fashion. At this stage of her life, however, Swartz could not completely resolve her conflicts through the written word.

The latent dissatisfaction Swartz felt with herself, and her increasing depression, were compounded by not being able to become pregnant. She and Melvin wanted a child and so sought medical help. Her doctor recommended hospitalization for extensive testing. This reinforced her despair, as even her body seemed to be betraying her. She was reminded of the early death of Frances Schwartz. While in the hospital, she drew herself as a crying mountain, in a wounded state. A mountain is a strong rather than a weak symbol, and Swartz now believes that even then, she was aware of her resilient strength.

In *Odd One Out,* painted around this time, Swartz portrayed herself as a bug outside a womb. She says that it symbolized being thrust from New York into an alien environment and feeling isolated. "Yet, I also was the child, impatient to hatch. I thought that, somehow, having a child would help me feel connected. There's a lot of anger here, repressed and left over from my childhood. I was still asking permission and giving control of my life to someone else. I felt I had lived most of my life trying to please other people. As a result, I felt ineffectual and not in control of my destiny."

About this time, Swartz read *Neurotic Distortions of the Creative Process* by Lawrence S. Kubie. Kubie's purpose was to shed a light on assumptions usually associated with creativity, such as "that one must be sick to be creative," which, he said, is "devoid as far as I can see of the least fragment of truth." Beneath their neuroses, Kubie believes those who strive to be creative always have a sense of dedication. His book provided health-giving insights to Swartz, who became aware that her own strength was sapped by her acceptance of others' ideas of what she should be, rather than her own. "I resolved to make art. My art was the one arena where I had control. My studio was the one place I could be myself."

Her art assisted her in the struggle to master her life, but Swartz found that she needed some sort of external, nonjudgmental support as well. In those early years of her marriage, she joined a group of women who had had similar experiences and needed to talk with each other for mutual support. The women came from diverse backgrounds and had different kinds of problems, but found they could trust the group. By listening to one another, they gave each other a strength they did not find elsewhere. A community of caring people, the group has lasted—with occasional changes in membership—for twenty years.

In 1964, Swartz gave up her teaching position but continued to work with the Head Start program around Arizona. She gave lectures in the field of creativity and taught courses in watercolor to teachers. Privately, she maintained her habitual commitment to intense reading and study of philosophy and art journals. In her art, she set herself a tough regime of painting with the intention of making discoveries.

Classes in painting and lithography at Mexico's Instituto de Allende occupied part of Swartz's summer in 1966. While there, she did her first lithograph. She retained the fluidity of her style, but adapted it to the tonal and linear requirements of lithography. Brisk contrasts and textural variety

were incorporated in a series on the theme of the egg. These pieces related to her ponderings about being a woman, the womb, and giving birth, preceding her pregnancy by several months. This was a time of psychological conflict and ambivalence, and Swartz enriched the texture of her life by voracious reading. She was motivated by a search for an alternative to her conservative models. Though embarked on a life of marriage and a hoped-for pregnancy, she still faced the question of priorities. How much creative time could she share?

Nature was the center of the embryonic philosophy Swartz developed. To feel attuned to, or in union with, nature was her conscious desire. "I wanted to participate in it rather than just be an observer of it," she recalls. For her, having a baby was a bonding to the positive ongoingness of life. Julianne Swartz was born on April 27, 1967.

"I loved being pregnant. I loved breast-feeding and all the accouterments of oneness. My visceral connection with nature had begun. It also marked the beginning of my acceptance of being in Arizona."

This connection prompted Swartz to make rapid changes in her work, which became more abstract and experimental. "It took all those years, from '59 to '67, for me to let in the light. I painted *Dust Storm at Saguaro Lake* on location after Julianne was born. It's much less stiff, less like an illustration and more involved with the scene than *Painted Desert.*"

After her daughter's birth, while she was enjoying being a woman and a mother, Swartz read *The Feminine Mystique* by Betty Friedan. Friedan held up a timely mirror to society and forced a generation or more of women to face the paucity of their options and their responsibility for changing their situation. The book left a residual itch of dissatisfaction. Despite the joys of new motherhood, Swartz was vulnerable to Friedan's message, and it made her sharply aware of her split allegiances: one to her family, the other to herself.

The idea of being divided made its way into the modest painting enti-

tled *Like a Raindrop.* As a ground for the work, Swartz ripped paper to create a softened edge; then she tore a circular form from another sheet of paper already spontaneously covered with a flowing triad of red, yellow, and blue watercolor. She glued the circle to the distressed ground sheet in an effort to integrate in a work of art a disordered form with an ordered one. Done in 1967, it is an early example of working with order and chaos, or what Swartz describes as the dichotomy of "pushing at opposites." The torn edge and flow of paint were methods Swartz preserved; several years later, she returned to the notion of gluing layers of paper together.

Swartz had achieved motherhood and found time to create, yet stress began to build once more. An example of what she was trying to squeeze into her life so soon after giving birth is enough to explain her feeling of exhaustion: Swartz drove herself in her painting with an intense desire to expand her command over nontraditional watercolor; simultaneously, she served as creativity teacher and consultant to the Head Start Program. Unaware of her need for their understanding and approval of her work, Swartz's parents expressed concern for her health and family. Melvin Swartz realized the depth of his wife's commitment to her art but he, too, worried about her stamina. As a teacher and a consultant, Swartz could be assertive and professional; at home she struggled to overcome her dependency. In her art, she was finding her own voice and distinctive style as a painter of naturalistic, understated watercolors.

The inner conflict, however, had not abated; as a result, she was susceptible to things that promised relief or a new direction. While vacationing in San Diego in the summer of 1967, Swartz was attracted by an ad for a "More Joy" workshop. The ad said "Learn to use your creativity." Swartz thought the workshop might be useful in her creativity classes as well as in her personal life, and so she, Melvin, and the baby moved into the growth center for a few days while she took the course.

At every shift in the eternal drama of transformation, there is offered the divine gift of choice.

FRANCES G. WICKES

in large, undetailed forms that were achieved by pouring one layer over another. This early example of pouring was done on wet paper. Swartz built up layers to create density without sacrificing transparency. In such experiments, she made discoveries upon which she would build for years to come. While in later years, pouring became an important method of applying paint, in 1968 it was not typical of her technique, aggressively developed during the time Swartz could free for work in her studio.

"More and more, I was jealously guarding the time I could spend in my studio. Finally, I put Julianne in a good day nursery so I could paint more often."

Swartz also experimented in an effort to push beyond lyrical abstractions. In a series entitled *Staccato,* she created a large number of pointillist works. This was her first work developed in a series through numerous permutations, as a form of concentrated exploration of a single theme. Her *Staccato* paintings were painted with a freedom not unlike that associated with Pollock. Jackson Pollock, who painted his famed drip paintings by moving around a canvas that was stretched out on the floor, dropped paint freely onto the work and opened the way for an unrestrained approach to the application of paint. Such a sense of freedom appealed to Swartz.

Pollock is quoted by Frances V. O'Connor as follows: "The source of my painting is the unconscious. I approach painting the same way I approach drawing. That is, direct—with no preliminary studies. . . . When I am painting I am not much aware of what is taking place—it is only after that I see what I have done." Swartz experienced some of that same sense of automatic, unpremeditated flow between herself and her *Staccato* pieces. She realized that she had made a breakthrough in this work that was unlike anything else she had done. The freedom she allowed herself in these paintings was, in effect, a self-granted inner permission. In the future, she could be free to explore new approaches in her art. The risk of

By proceeding consistently in natural scientific thinking to the living reality, our modern consciousness may be widened and extended to compass the mysteries of the world.

THEODOR SCHWENK

28

Japanese landscape artists have a centuries-old tradition of watercolor painting with masterful control of brush and value. On the west coast of the United States, Oriental influences, in combination with virtuoso techniques, led such luminaries as Millard Sheets, Rex Brandt, and Phil Dike to their individual styles of semi-abstract watercolor landscapes, energized with gracefully dynamic brushwork. German artist Emile Nolde painted lyrical watercolors during the thirties; their emotional and chromatic weight made them equivalent to oils. The legacy of his expressionism in the watercolor medium is a forceful alternative to the cooler intellectual analysis stemming from Cézanne. The power of watercolor in the United States is a lasting phenomenon, and diversity is one of its strengths. Particularly among twentieth-century American artists, watercolor is taken seriously as a versatile, expressive medium.

Although Swartz developed her lyrical abstractions in relative isolation, she was aware of this historical development of watercolor and responded to those artists whose work depended on impulses similar to her own. An educated artist cannot retain an "innocent eye." Through journals, monographs, catalogs, and exhibitions, visual education continues beyond schooling. Every artist who evolves a style does so from illusive elements that inhabit his or her visual storehouse, but the actual breakthrough in the privacy of the studio, when one dares to apply paint in a new manner, is a solitary thrill, dependent upon no one else. It is the individual artist who must act courageously in an effort to grow. Swartz is well within this tradition; she has studied, gone to exhibitions, and attended classes to add to her repertoire of technique. Her paintings were recognizable for their lyric brushwork, loosely painted washes, pleasing color, and sophisticated composition. She became known, at first, through watercolor exhibitions in her own area, but her reputation widened as she sent her paintings to exhibitions outside Arizona.

In *View From Jerome,* painted in 1968, the flow of land was captured

"All along, I was looking for a guru—someone outside of myself who would give me an answer. But the workshop turned out to be an encounter group. The object of their aggressive tactics was to force a person to open up and become vulnerable. Far from developing creativity, it was actually destructive of the confidence I had won for myself. Nothing could be worse for someone like me, with emotional highs and lows, than the soul-baring, psychological attack of a sensitivity session.

"In rethinking the experience, I realized I could not assign judgment of my work or myself to those who view art as some kind of therapy. When gurus fail, I find I'm challenged to stimulate my own opinion by endless reading and study. I began studying the writing of creativity scholars such as Frank Barron, J. P. Guilford, June McFee, and Elliot Eisner."

All these authors stress the trust creative people have in themselves. Through her own inner creativity and her increasing reliance upon its guidance, Swartz further developed her nature-based connectedness with her physical environment. As her work became more abstract, Swartz was pleased that it also grew stronger. She resolved to reinforce both the abstraction and the power by painting as directly as possible.

In the course of developing her direction, Swartz explored the use of flowing color in her lyrical abstractions. She recalls that, for a time, she was the only artist in the Arizona Watercolor Society who worked from the landscape in an abstract style.

The path of lyrical abstraction has been well marked. In the European tradition, it had a soaring beginning with Turner, whose first medium was watercolor. A century later, Cézanne recorded broad vistas with a form of prismatic reduction that continues to affect Western art. John Marin's shorthand brushwork in fractured landscapes owes a debt to Cubism and, more distantly, to Cézanne. Georgia O'Keeffe has distilled the southwestern landscape to pure form in an abstract style that grew from her early study of Oriental aesthetics and watercolor techniques. Chinese and

1967
Dust Storm at Saguaro Lake
watercolor and ink on paper
22 x 30 inches

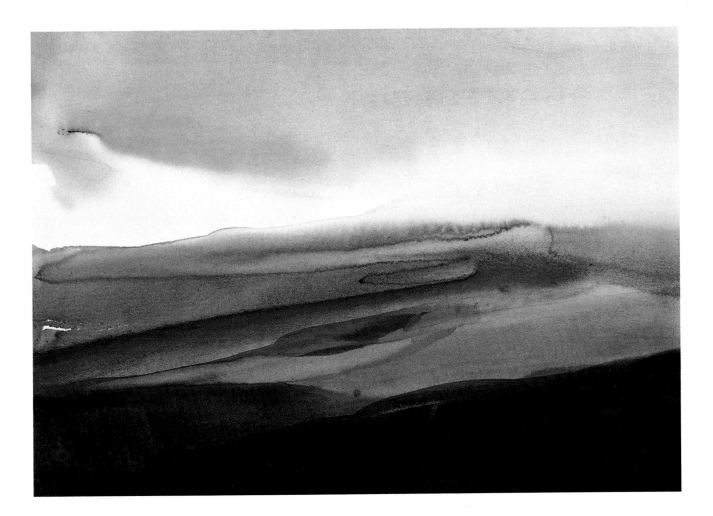

1968
View From Jerome
watercolor on paper
22 x 30 inches

losing the stature she had already attained with her lyrical landscapes was now an acceptable one.

"I had made a reputation as a watercolorist, but it wasn't enough for me. What is significant about *Staccato* is that I was trying to push watercolor as far as I could. I wasn't satisfied with painting pretty scenes anymore, and I wanted to gain more power in my work because I was beginning to feel it in my life. I was beginning to feel comfortable in Arizona and in my own place.

"I started experimenting, not only with new shapes, such as the oval in *Staccato #1,* but also with new ways to apply paint. My commitment since moving to Arizona had been to paper. At first, I used only watercolors, but, in 1968, I switched to acrylics on paper. I used them in a transparent way. It was a necessary, conscious decision, made so that I could work larger and stronger. My idea was to use paint more generously and with more courage. Every time I have developed a technical expertise, I have felt driven to move on. There's a real danger of falling in love with the process and thereby neglecting creative vitality. At this time, these restless, self-actuating changes that seemed to force me along were very disturbing. I had no explanation for what I took to be dissatisfaction."

Swartz became interested in the idea of synchronicity during this period, after reading Amelia Jaffe's book about Carl Jung, entitled *The Myth of Meaning.* Jaffe writes: "Jung introduced the new concept of synchronicity as a necessary principle of knowledge. He defined it as a 'coincidence in time of two or more causally unrelated events which have the same or a similar meaning. . . .' "

"With increasing frequency I had synchronistic experiences. In the studio, I tried a variety of approaches and came to trust that a synchronistic combination of action and response would occur, leading me to a discovery. When a work had a special quality—something distinctive

I actually moved around the paper in a rhythmic, dancelike way to throw the paint. I built up the dots of splattered paint into layers, a harbinger of my later work with layered materials.

BETH AMES SWARTZ

30

about it—I'd save it to see where it would lead. My early art was an outgrowth of continual experimentation. Nothing that happened in my studio was meaningless: in fact, it was the apparently random discovery that opened a door in my mind to my subconscious.

"Jung also writes about a person's sense of destiny. I felt compelled to be an artist. With no support other than Mel, without public stature, I drove myself relentlessly. My work has always driven me close to the edge. Often, my art is a precursor of events that occur six months to a year later. The year 1968 was a real breakthrough for me as an artist. I moved from watercolor to acrylic, began using a larger format, actually moved around the painting on the floor or outside, and moved from realism into abstraction."

As the artist notes, the *Staccato Series* demonstrates a fundamental change in the direction of her approach. Prior to this period, Swartz's growth was largely technical, as she asserted control over watercolor and developed her own style. After the *Staccato Series,* she felt a sense of release from traditional watercolor techniques. Perhaps even more significant was her change of focus. Instead of painting an illustration of landscape, she began to think in terms of expressing a personal response to her environment. She moved closer to her theme emotionally, and further away from it visually. Her study of creativity led her to develop an attentiveness to her own reactions, to senses other than the eye. Feelings became prompters and she was beginning to trust them.

1969
Joinings
mixed media and acrylic on paper
4 panels, 19 x 16 inches each

TRANSFORMATION

*If women are different from but not inferior to men, then perhaps nature is
different from but not inferior to spirit . . . women's quest is for a whole-
ness in which the oppositions between body and soul, nature and spirit or
freedom, rationality and emotion are overcome.*

CAROL P. CHRIST

In the late seventies, Swartz was included as one of ten artists who
exhibited selections of work from the previous decade in "Ten Take
Ten" at the Fine Arts Center in Colorado Springs, Colorado. To make
selections for the show, Swartz reviewed more than just the past
decade. She went through twenty years of growth by studying the work in
her own collection. *Joinings,* a four-panel exploration into oil-based inks,
was rediscovered in this private retrospective. Painted in 1969, during a
period when nature was the source but not the subject of her art, *Joinings*
was originally rejected by Swartz because it was not light and airy. Its
heavy layering, rich color, and large scale foreshadow the development
she was to make a decade later. When she painted it, her interest was in
the texture that resulted from moving through wet areas with oil-based
inks. In addition, she used chalk and watercolor in large flowing gestures
to densely cover the paper. By aligning four sheets of paper and treating
them as one, Swartz attempted to construct a scroll-like effect, an idea to
which she returned in 1980. Between 1969 and 1980, Swartz formed new
mental bonds with nature's qualities—not only its visual appearance but
its vibrational sensations as well. She could not take the discoveries made
in *Joinings* any further until she had explored her tenuous connections

with the earth; hence, she forgot it. When she found it again, it took on added significance.

As she entered the seventies, Swartz tried to express added emotion in her work. She painted *Sun Spot* in 1969: a thicket of large gesture marks and flowing color on paper that she had distressed by scratching with her fingernails and palette knife. The scratches caught the paint differently than the smooth areas, and the gently flowing, pure color was offset by the violent kinesthetic scratching. Two forces, order and disorder, were held in a fragile balance. This dichotomy between order and disorder was to become a central consideration in her work as she advanced in her personal, philosophical, and creative sphere. The impetus for much of this evolution was Swartz's continued study.

Throughout the late sixties, she read poetry and investigated the writing of psychologists. She was engaged by e. e. cummings, T. S. Eliot, and Carl Jung; connections formed in her mind between creativity, philosophy, metaphysics, oneness, and nature. Many of the basic components of her current philosophy regarding the universe as a connected organism have their beginnings in studies from this time.

In 1970, she began moving into the community, inspired by a feeling of responsibility. "It was an awakening to the sense of alliance with others. I had to involve myself," she explains. She became an activist in a group that sought equal opportunities for women by going to businesses and attempting to convince them to hire more minority women. A painting she did that year, *Freedom Now,* presents a female form in the shape of a cross; the implication was a protest. Abstract bands of color framed the freely drawn figure suggested within the color areas in the center. Yet, in her personal life, Swartz continued to accommodate her art and motherhood. Jonathan was born in 1970, and once again, she felt deeply connected with nurturing.

The summer after Jonathan's birth, his parents took a raft trip down the

In my present mood don't like anything
 much.
Want to be crazy
Will be crazy
Like to paint some damn fool pictures—
 no you fool
 they may be foolish but damn foolish?
To paint disorder under a big order.

JOHN MARIN

Swartz made a trip to the Los Angeles County Museum of Art late in 1970 to see a show of John Marin's work. She noted a painting in which he had cut out a yellowish sun form and collaged it to his watercolor. His free-wheeling watercolor technique inspired her to attempt such layering in her own work, in order to achieve a freedom from the flat structure of the paper. She developed a way of using torn pieces of painted paper that resulted in a projecting collage, one that enhanced the two-dimensional surface of the painting.

Swartz moved ahead steadily in her experiments with this technique. *Opening Her New Wings At Dusk,* painted in 1971, evoked the theme of a woman awakening to herself. Collaged layering on the upper area is both darker and denser than the watercolor layers in the lower area. The random network of light tendrils is dramatized by intense darkness.

Swartz continued to intuit correspondences between aspects of nature that had seemed separated, particularly between woman and the earth. She was excited by the idea that patterns of similarity exist throughout the universe. Her awareness of connections was strengthened as a result of her trip down the Colorado River, and, for several years, she responded to the trip artistically; it was as though by going into the canyon she had made a passage through her inner landscape, as well as encountering an awesome phenomenon at close range. It had a transforming effect on her, spiritually and aesthetically. She experienced a heightened awareness of her place in nature, a confrontation with and release from fear, and a feeling of technical power. Swartz became charged with creativity.

The summer of 1971 arrived and the whole family went to the Instituto de Allende in San Miguel de Allende, Mexico, where Swartz experimented with pouring stains of color on canvas. She admired the stained canvases by color-field painter Morris Louis and others, and she was attracted to the possibility of painting larger pieces than she could at the time on paper. Swartz was dissatisfied with the results, though, and

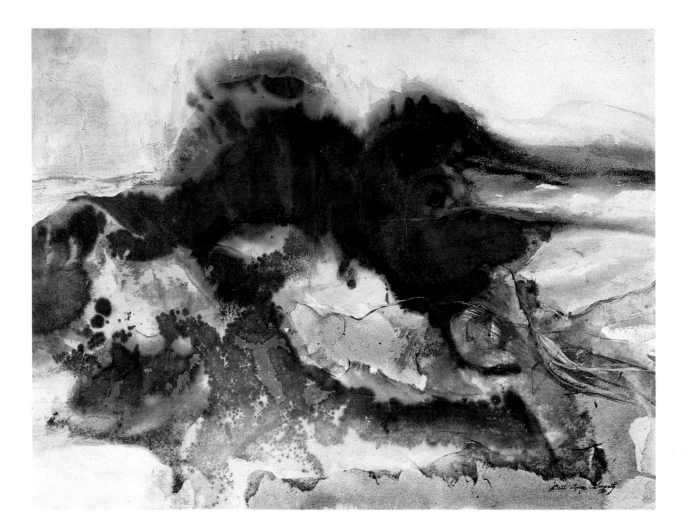

1970
She is Joined to the Soul of Stone
mixed media and acrylic on paper
32 x 38 inches

Colorado River, into the Grand Canyon. This experience stimulated a new imagery and a new dimension in the artist's philosophy.

"That trip marked another huge transformation in my work. I did lots of sketching and as I studied the forms of the rocks, I began to notice feminine forms within them. It made me feel involved with the land in a new way. We climbed through three billion years of geologic time, went to sleep at sunset and awoke when the sun rose. The nuances and variability of the colors were overwhelming. I experienced a special kind of connection with nature and it had a profound effect on me. After that, I began hiking at home, and being in the desert affected my awareness of it.

"From this experience grew a whole body of work that shows women coming from the earth. For two years, I experimented with this theme, relating myself to the topography. Going into the canyon was a turning point in my life. An archetypal female figure in a landscape setting was an elemental change in my work that showed at last I felt connected to my surroundings. I knew I was home."

Selected pieces of the work that grew from the Grand Canyon trip were shown in Mexico City at Galeria Janna, whose director learned of Swartz from a friend in California where Swartz had been exhibiting. Toby Joysmith, an artist and art critic who reviewed the show, described Swartz as a "master of the controlled accident." He saw a relationship in her work to the poetry of Robinson Jeffers, who also personifies the elemental forces of nature.

With the title taken from a poem by e. e. cummings, *She is Joined to the Soul of Stone* was painted after the Grand Canyon trip. It was an abstraction of two ideas: the shape of a woman and the sensation of canyon walls. A fluent transparent red runs down the rock, whose formation looks like a woman's body. In this work, Swartz is identifying the strength of the stone with the strength of women. It is an expression of the unity that she sensed in the canyon between herself and the rocks.

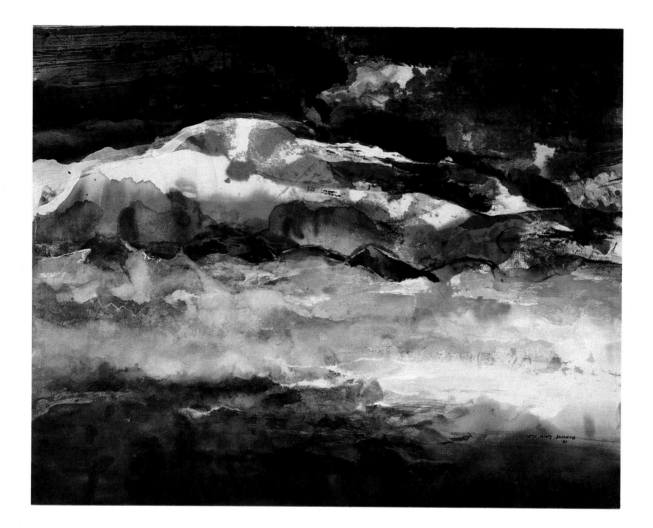

1970
Let the Heavens Say She Must #1
mixed media, acrylic, collage on paper
19 x 24 inches

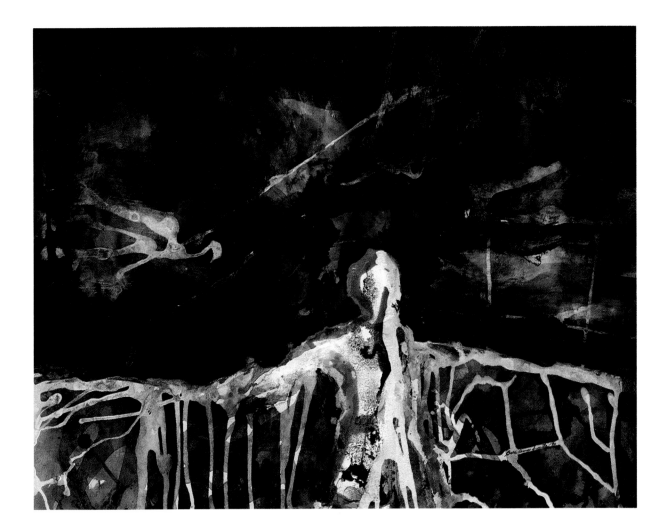

1971
Opening Her New Wings at Dusk
acrylic on paper
22 x 30 inches

threw out the work of an entire summer. "I couldn't find my own voice on canvas then," she explains.

When she returned from Mexico, Swartz still felt driven to focus her attention on color. It was basic to the direction she sought in her work. For the next two years, Swartz studied color theory privately with Dorothy Fratt. Before moving to Phoenix, Fratt was a part of the Washington Color School, a group that included Morris Louis. Swartz learned from Fratt that each color has its own symbolic voice. One color affects an adjacent color in such a way that a third voice is created, separate from that of each alone. This two-year detour in her work firmly convinced the artist that she needed what Fratt could teach her. Color theory became second nature. "Color theory enabled me to go on and add another layer to the work."

Swartz focused intently on color; she spent long hours in the studio. Ultimately, it became necessary for her to find time to withdraw from such demanding concentration, and she found relief in transcendental meditation. "The need to quiet the mind is universal. With my kind of personality, it is especially crucial." She allocated time each year to spend in meditation at the nearby Franciscan Renewal Center.

The combination of practicing meditation and increased knowledge of color theory motivated a long exploration for the artist, which she entitled *Meditation Series.* She began in 1971 with six oils on canvas, but was not comfortable with the medium and returned to watercolor on paper. In this series, a vibrational effect of "color voices" enlivened the paintings and a dynamic tension underlay their apparent simplicity of design. Here, for the first time, she succeeded in satisfying herself while working only with flowing layers of color.

Swartz continued the *Meditation Series* for the better part of two years. She then applied her growing power to a series entitled *Restless Oral Darkness.* The integration she had made in her art—control over aesthetics combined with a steadily deepening philosophical basis for her

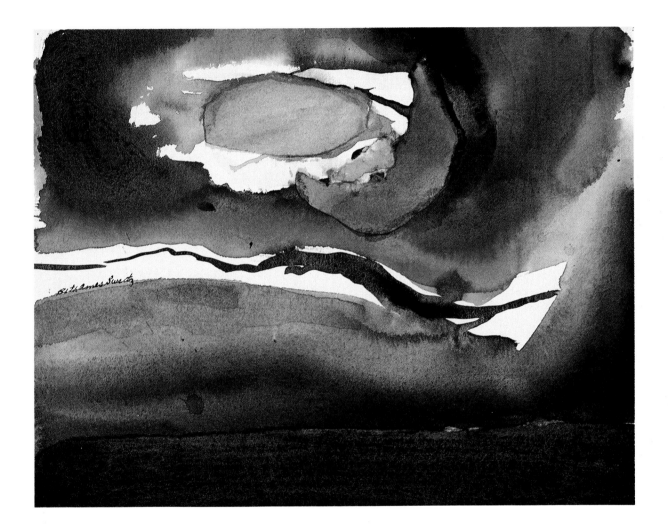

1971
Meditation Series #10
acrylic and collage on paper
16 x 20 inches

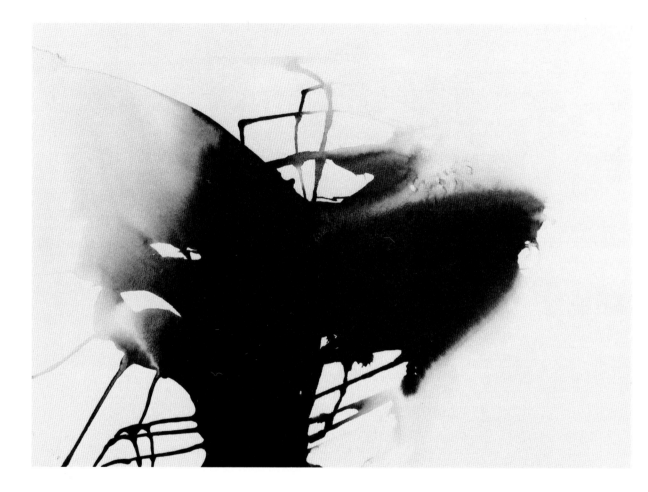

1973
Restless Oral Darkness #2
acrylic on paper
32 x 38 inches

work—derived both from her life experiences and from studious reading. She did not, however, believe that this artistic integration extended into her life to the same degree. She struggled in these paintings to break out of psychological restraints and into a new level of assertiveness. Angry paintings on a larger format than the *Meditation Series,* they have dark and passionate tones of black and deep reds.

Throughout the two years of working on color theory and developing her new series, Swartz did not show her work in galleries. In 1971, though, she did become a founding member of The Circle, a mutually supportive group of Arizona women artists who exhibited together, particularly in out-of-state shows. One was held at the Joslyn Museum in Omaha, Nebraska. While the group lasted—that is, while it gave nourishment to each of its members—it provided Swartz with an alternative to the loneliness of the studio.

Back and forth, between the need for solitude and the need for mutualism and communication, Swartz turned inward and outward, expanding and contracting her focus. Every few years, after achieving new insights, she reached out to share them. Through her participation in The Circle, Swartz continued her professional life and gained recognition outside her region while in the midst of a radical change in her art.

Projected Power, another series in which Swartz gave voice to frustration and an urge to control both the progress of her art and her life, was a protest against conditioned self-effacement. In this 1973 series, she was primed, practiced, and ready to make an impact. These paintings are transition pieces, more in the nature of a private primal scream than a public demand for attention. They also foretell her work of the following year, which deals with the elements of fire, water, earth, and air. Even before encountering Zen, her next philosophical exploration, she was practicing it in these spontaneously attuned works.

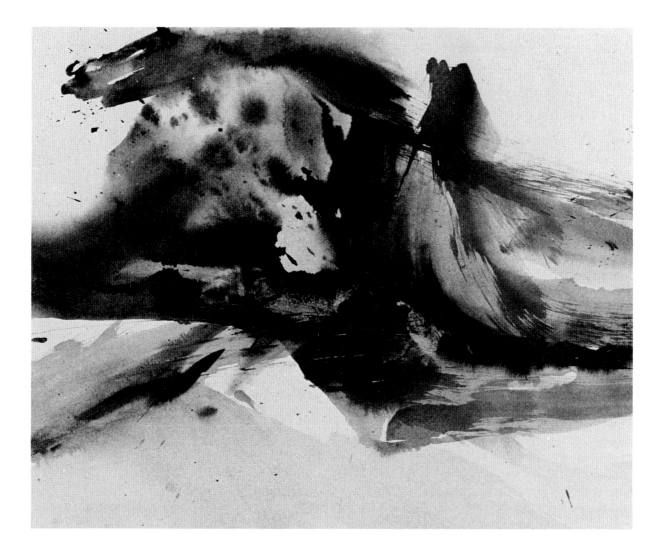

1973
Projected Power
acrylic on paper
31 x 38 inches

In June 1974, Swartz attended a creativity conference sponsored by the Creative Problem Solving Institute in Buffalo, New York. George T. L. Land, systems theorist and author of *Grow or Die,* lectured at the meeting. Land believes that growth is a force which can be traced through definable stages, and in his book, he presents a systems view of growth that he finds consistent throughout the known universe. The development of a creative artist is one of the examples he uses to explain his theory in action.

Swartz was searching for a structure of experience similar to her own. She had undergone unsettling, yet upward-moving, changes in her art for a decade. In this period, she had left watercolor behind and was painting with acrylics. She was working on a larger scale and in untraditional ways by adding collage and layers of paper to her work. After her experimental *Staccato Series,* she released more emotion as violent expressions. "Each time I became facile, I forced myself to change, though I was afraid of the unknown."

Meeting George Land was a crucial event in Swartz's life, a catalytic force in her thinking. Land offered an explanation for her own pattern of growth and some of its accompanying fears, especially the fear of failing when she tried something new.

Land, who became one of the artist's trusted friends, outlined growth in three stages: Initially, there is an implied chaos or disorder. The first effort is directed to process information and to become organized. In the case of an artist, this would be the learning stage of gaining control over materials. Once a status quo is reached, a stage of mastery is entered after repeated practice to impose order on the environment and to develop expertise. Many artists reach this level and are afraid to leave it because their style has acquired a following and recognition. The final stage is an innovative one. After expertise no longer satisfies, a cooperative or mutualistic effort begins, marked by sharing reciprocally with the environment to reorder or integrate a new disorder.

The Zen believer seeks constantly to become one with nature, to assimilate himself into it.

YASUICI AWAKAWA

"Growth," says Land, "is always a matter of making connections or bonds at higher levels of complexity. Things come into relationships or associations with each other which were not previously connected. . . ." There are crisis points in the natural cycles of growth when a point of departure is reached from one stage to another. Land posits that after successfully completing a cycle of growth, one moves into the beginning of a new cycle; this is an event he terms transformation. He has written: "In order to reintegrate any sort of complete structure into a larger whole, there must be a complete 'destructuring' of what exists. This has been seen as the 'need to destroy' in order to create."

Land's theory helped Swartz to understand why transformation is inevitable and the fear of it is natural. She describes a numinous experience that occurred while she was in Buffalo: "The night after meeting Land, I fell into a fitful sleep and dreamed, or 'saw' in a super-real vision, a gathering of discarnate beings in white robes around a goddesslike figure with a glowing aura. I was told 'Now you are one of us. You have a special purpose in the world yet to be fulfilled.' The vision terrified me, as it seemed to impose intolerable burdens of responsibility that I was not ready to accept. Perhaps I was afraid of losing my growing and hard-won sense of independence. Six years later, I realized the 'vision' related to the concept of the Shekhinah, the feminine aspect of God." Swartz's vision troubled her, but she found Land's interpretation of creative growth reassuring. He had articulated a crucial concept for her and described what she had been doing in her studio, instinctively, for the previous fifteen years.

Swartz began reading about Zen philosophy in the fall of 1974. She sensed a relationship between Zen and her fascination with geographic forms. Zen harmonized with her belief in spontaneous energies that vitalize every aspect of life, and its emphasis on basic elements inspired Swartz's next stylistic transformation. She had learned the effect of color

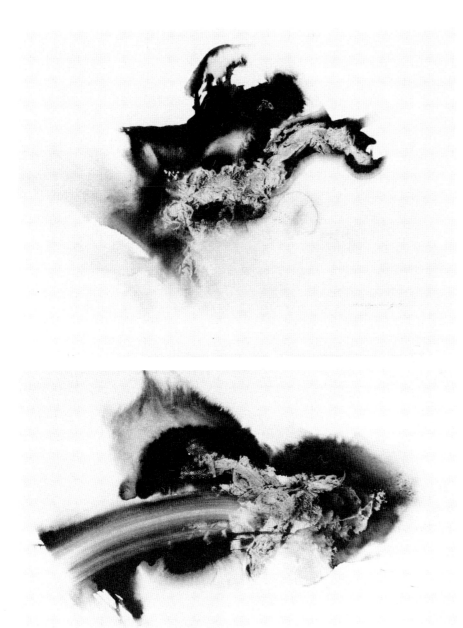

1974
Umi Series #1 and #2
acrylic on paper
22 x 30 inches

over color while studying color theory; by pouring transparent layers of acrylic on watercolor paper, she created luminous, richly colorful, sheer compositions that seemed unpremeditated but were controlled to achieve the mixtures she wanted. Zen provided her with a starting point for a new direction.

In order to express this newly gained point of view, she undertook four series of paintings related to the elements. In the first, entitled *Umi,* Japanese for "water," she used water and color to suggest water. Her next series was devoted to air; she returned to the *Air Series* again over the next two years. *Flight* was her third Zen-inspired series. In it, she attempted to "capture a moment in time"—her time, her motion—by leaving only traces of gestures on the sheet in much the same way Zen artists of seventh-century Japan were taught to transcend thinking and act spontaneously from the inner self. *Prana,* which means "spiritual energy" in Sanskrit, was another of her element series; in it, she asserted her acceptance of the Zen belief that spiritual energy is a part of the universe in the same sense that water is part of the earth. The more restrained and closer-to-the-body movements she used in her *Staccato* pieces were released in these element paintings as a form of active Zen. By pouring paint directly across the paper in large sweeping gestures, she expanded the work's grace in a visible demonstration of confidence. The paintings, so transparent and direct, either succeeded or did not. For every work she saved for exhibition, she abandoned many as "unsuccessful." After repeated efforts made with this experimental attitude, learning from mistakes and retaining what worked, she eventually found satisfactory combinations of color and gesture. She became more expert at judging whether these abstract works were in harmony with her knowledge of color theory—but she still studied them reflectively for a long time before exhibiting them.

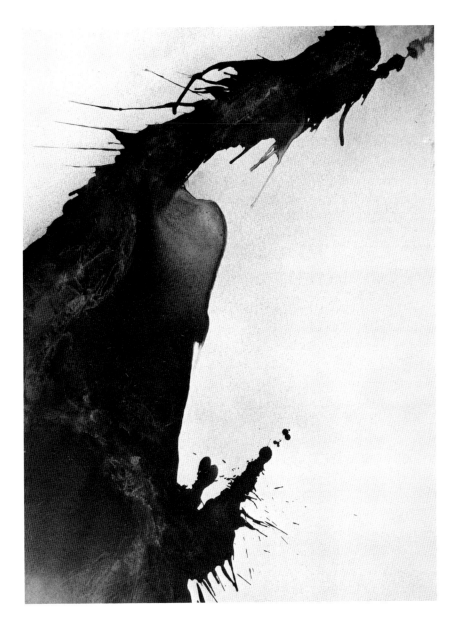

1975
Flight
acrylic on paper
30 x 22 inches

Air Series #2 was painted in delicate washes by airbrush. Swartz taught herself to use the airbrush so that she could actually incorporate the use of air in this series. In some areas, there is a flow of water and, on dry areas, a breath of airbrushed color. Layers of rice papers treated in this way evoke the moving quality of air. Another device, that of linking panels together, extends the apparent size of the work. One of the inspirations for these air paintings came from a girlhood experience at a summer camp in the Adirondacks, when Swartz saw the Aurora Borealis glowing in the northern sky. The sense of night and day blending as one remained in her memory and influenced this series and later ones, as well.

Each decision an artist makes has its corollary in the choice that is rejected. Throughout the seventies, Swartz followed the path of abstraction, rejecting realism. Her talent lies elsewhere, and so does her taste. Swartz excels at symbolism and subtle allusion. Even when she returned to drawing in the eighties, it was not as a representational artist but as a symbol maker. Driven toward change, Swartz rejects a development when it has run its course and the initial challenge is gone. When she reaches a frontier, she has a need to push on, topping the next hill. It is not other artists who are pursuing her in this flight; it is herself.

In late 1974, Swartz turned from her earliest element paintings to a long preoccupation with the *Earthflow Series* that lasted until 1976. After a year and a half of concentration, though, she felt it had ebbed. "I was pushing myself closer and closer to the edge emotionally and also with my work, as I tried to find something new to say," the artist recalls.

The change that was to come next in her art was related to her family. Swartz had long carried negative impressions of her childhood: she thought of herself as a misfit, although she loved her family and respected the quality of life her parents provided for her.

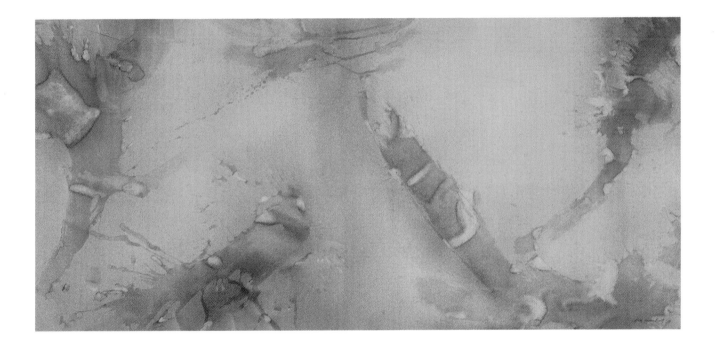

1975
Prana Scroll
acrylic on paper
48 x 100 inches

"My father instilled in me a love of learning for its own sake, a striving for excellence, and a deep belief that with hard work, I could accomplish my goals." The artist's mother provided her with the necessary entry to creativity through lessons and encouragement of her talents. Swartz remembered many long philosophical talks she had with her mother over the years, and how they had connected during those moments. It was a shock to Swartz when her mother suffered a heart attack in 1976. Memories of home and her unresolved emotions about her place in the family were suddenly overpowering. These feelings shook Swartz's precarious sense of independence and sureness, and came at an important juncture in her creative life.

Worrying about her mother brought Swartz face to face with her own fear of death, and it was for this reason that she attended the lecture given in Phoenix by Elisabeth Kübler-Ross during a symposium on "Death and Dying." Swartz hoped to hear something of comfort. Kübler-Ross documented the experiences of patients who had clinically died but were revived and survived. In doing so, she compiled a credible rationale for a belief in life after death. The famous doctor spoke of the opportunity for growth that accompanies pain and suffering. She emphasized an underlying purpose in life and its basic tendency toward growth. For Swartz, Kübler-Ross's message was reassuring and underscored her renewed conviction that growing as an artist was purposeful. After hearing Kübler-Ross speak, Swartz was better able to order her thoughts and emotions; and her work was affected in a dramatic fashion.

During the summer, still concerned about her mother, Swartz invited Jonathan to share some painting time in the studio. The sturdy six-year-old, with healthy pleasure, began painting immediately. Something about his spontaneity galvanized his mother and she freely expressed her emotions in a similarly unpremeditated way. She printed "I Love Mommy" in watercolor and stroked transparent shades of red, yellow, and blue all

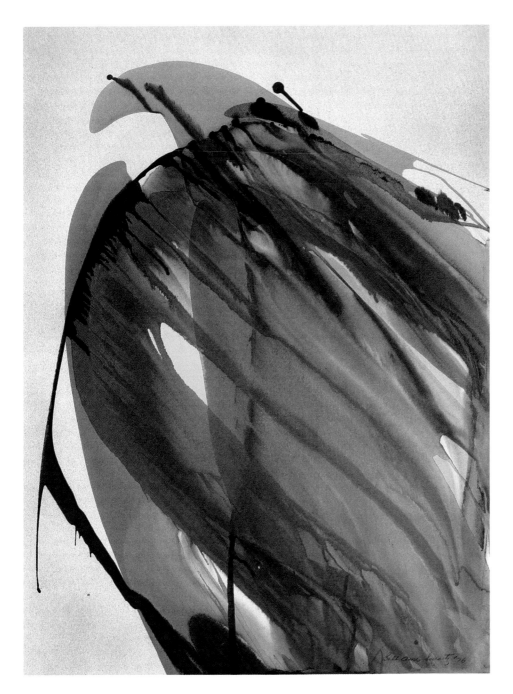

1976
Earthflow #40
acrylic on paper
30 x 22 inches

around the words. On another sheet, she wrote "Fear of Death." She still connects this spontaneous work with Jonathan's child art and believes the pieces to be authentic expressions with a new sort of direct power and energy.

Later, Swartz spoke her thoughts into her tape recorder; she expressed her devotion to her family, her assessment of her work, and her ambivalent emotions: "I want to break through into a new skin—a new stage—holding nothing back. . . . I've been doing all this crazy stuff and it really scares me because I am getting in touch with something very basic. . . . These new paintings are yelling and screaming . . . unless I get in touch with this anger, I'll be living a lie. I'm deeply committed to a life's work of making art, and I'm deeply committed to nurturing this family. It doesn't have to be mutually exclusive. I want both. . . . Fear of success is very much tied up with being a woman. Mother used to say if you can't be good to your nearest and dearest, what good are you? I love my family. I love the commitment, and yet, sometimes it's like a noose around my neck. If I make an impact with my work, will I lose my family?"

In this taped exchange with herself, Swartz recalled good times with her children and husband. When Melvin Swartz started writing his book, *Don't Die Broke,* a layman's guide to legal and tax problems, they built his den in part of her former studio space. Together, they made room for each other's needs and talents. Yet, in her thoughts, Swartz was sharply confronted with the fact that her path was slower than that of single-minded women, ones without her obligations—those who were making it at thirty. Is the women's movement only for them, she wondered? Is anything more important than serving as a model for children as they develop? At the end of the tape, she expressed her belief in the family as a microcosm of life, a nurturing habitat from which its members entered the outside world and also took shelter from it.

Swartz also found support during this time from reading Elizabeth

Janeway's *Between Myth and Morning,* which addresses the old image of the good woman. "The old image has grown so small and so narrow that it has cut out a whole range of feeling, and, by so doing, it makes our responses smaller and less valuable than they should be. . . . Let us put the old image gently aside and see ourselves not as good women, but as good artists." Swartz did what Janeway suggested: She redefined herself.

Over the next few weeks, Swartz continued to explore the ideas she had had during Jonathan's studio visit. She developed the intense, slashing series of acrylic watercolors she entitled *I Love Mommy.*

Dorothy Ames's health remained precarious for some time. It was during the danger period, when she did not know whether her mother would live or not, that Swartz literally exorcised her apprehensions in a new form of art. Her fear for her mother's life had been the catalyst for another transformation; her art was a way of sharing the worry with her family and of offering support to her mother. To her great relief, she was told that her mother would survive. Swartz, too, recovered from fear with the help of her art. She had learned that by expressing her inner nature, she could expand creatively and strengthen and balance the duality she knew was part of her nature.

The series that Swartz created, *I Love Mommy,* was a private expression; she did not exhibit most of these paintings until several years later. Her reputation had been growing rapidly as a result of her work with the elements and the Zen paintings; those flowing and lyrical nature-based abstractions were known to John Armstrong, Visual Arts Manager of the prestigious Scottsdale Center for the Arts. When he invited Swartz to prepare a show to be presented in February 1978, he and Swartz both expected the show to feature such work. At the time, neither of them could know that Swartz was soon to have an experience in Israel that would fundamentally alter her art.

In October 1976, when Beth and Melvin Swartz went to Israel, they

were profoundly moved by visits to the Memorial to the Holocaust, where an eternal flame honors millions of Jews cremated in the ovens of Nazi death camps, and to other centers of the Holy Land. "I had never been deeply involved with the religion of my birth, but in Israel, the fact of my Jewishness was inescapable," she says. In an onrush of emotion, she recognized her connection to those who had suffered and died. The Holocaust became real for her and the human terror of death, whose presence permeates Israel, was renewed.

After Swartz's return, the emotional effect of her trip led to a continuation of the experiments she had begun during the summer in her *I Love Mommy Series.* A general fear of death replaced the specific fear of losing her mother. Expressionistic developments in her style swiftly followed one another as she worked with great bursts of energy. Few of the results were shown beyond her studio. She knew the work was an important breakthrough, but it was too personal, too close for her to display at the time.

In one experiment, as she scratched words with a screwdriver on a sheet of paper in preparation for painting around them, the tool pierced the sheet. This disordering unleashed something and she began to attack the paper violently, using the screwdriver deliberately to rip the surface. "Initially, breaking through the surface of the paper was a physical breakthrough as I tried to actually get into the paper." In the process of painting *Inside Out,* Swartz pierced the paper and mutilated it by tearing patches from two edges. On this new surface, she painted muted swaths of transparent color emerging from a dark core. The restraint and control over mutilation and brushstrokes in this painting contrasted with the vividly colored and more frenzied application of paint in her *I Love Mommy Series.*

Within the few months separating that series from *Inside Out,* Swartz had done an enormous amount of work. She was developing a process that involved deliberate, controlled mutilation for aesthetic reasons.

Each one of us is born for a special reason and purpose, and each one of us will die when he or she has accomplished whatever was to be accomplished. The in-between depends on our willingness to make the best of every day, of every moment, of every opportunity. The choice is always ours.

ELISABETH KÜBLER-ROSS

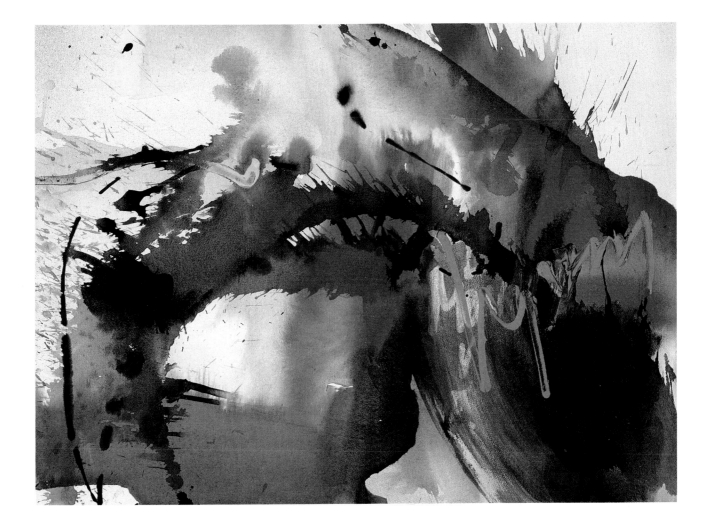

1976
I Love Mommy #3
acrylic on paper
22 x 30 inches

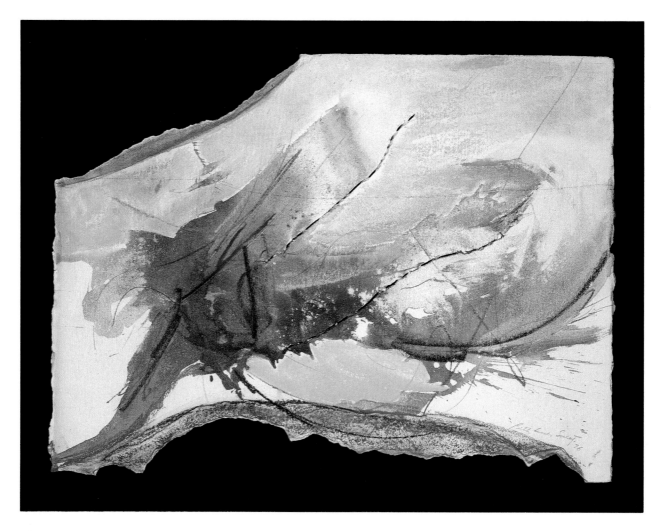

1976
Inside Out
acrylic on paper with mutilations
24 x 30 inches

Through her art, she was integrating the emotions caused by her experience in Israel. The artist/wife/mother of the summer was once again in the initial stages of new growth, working toward mastery. The earliest phase of this growth stage made her feel like a novice and caused a sense of dislocation, discomfort, and a fear of the unknown. With repeated practice, however, the artist became familiar with the new technique and became increasingly certain. Each time Swartz works through to stage one or stage two of growth as posited by Land's theory, her zest, mental well-being, and self-confidence return, and she gears up to meet the challenge of the next cycle of growth. To feel in control of her art is, for her, to feel at her best.

INQUIRY INTO FIRE AND RITUAL

Swartz's connection with her work became more kinesthetic: an active, stream-of-consciousness performance still related to her basic interest in the elements of water, air, fire, and earth. She was no longer content just to depict them. By pouring watercolor on paper, she had incorporated water in an image of water. By using an airbrush, she had made air a part of her *Air Series*. Swartz was attracted by the use of fire as an art medium, and considered how she might use it as a component of an image.

Fire had new meaning for Swartz after her trip to Israel. Throughout the ages, fire has symbolized prayer—the flames and smoke rising upward as a supplication to an unseen, but feared, God. Fire, when controlled, is one of man's greatest treasures. Out of control, it is one of the most destructive forces on earth; yet, it cleanses and renews. In Swartz's mind, there was also the image of the flame burning at the Memorial to the Holocaust, so far away but so vividly remembered.

"Working with fire was a way of dealing with death," she says. Her first torch was a candle held to the paper and moved about to create a tracery of design. She did one variation after another on the theme of smoke. These were process pieces, private exercises exploring the possibilities of fire. A breakthrough of major proportions came when she combined mutilation and fire. *Smoke Imagery #1* is representative of the experimental series.

To create this fragile homage to fire, Swartz mutilated her paper and scorched it with smoke. By varying the intensity and duration of the heat from her torch in its contact with the paper, she created values and shades of gray as well as ochre-toned edges. At first, she used a relatively safe candle; Swartz switched to an acetylene hand-held torch as she became more assured. After repeated efforts, she could partially control the smoke forms, just as she could pour color across a sheet with graceful gestures, creating her Zen abstractions of the elements. Gesture, smoke, and abstraction were synthesized in her *Smoke Imagery Series*.

Front view **Back view**

1977
Smoke Imagery #1
smoke, fire, ash, mixed media on paper
34 x 24 inches

Swartz formalized a ritual approach to painting in her *Banner Red Series*. The ritual included words, mutilation, burning, and pigment. Her first five pieces (there were forty-five in all) revealed an intense quality of emotional expression: The subjects ran the gamut from negative, destructive feelings—violence, fear, depression—to positive aspects of life and love. In each case, she slashed words on the paper. Doing this work, Swartz says, put her in touch with a whole range of emotions not dealt with before.

Her experiments revealed new possibilities and satisfied her urgent need to change and grow. "I showed my first fire experiments to John Armstrong and gave him the option of canceling the show he had booked for me in the Scottsdale Center for the Arts in February 1978. He expressed faith in my abilities as an artist and told me, in effect, to run with the ball." Swartz altered her plans for the show. Instead of exhibiting her color-stained, flowing Zen work, as she originally expected to do, she decided to develop her work with fire as a theme for the planned exhibition.

Her inclusion in the group retrospective, "Ten Take Ten," held in the Colorado Fine Arts Center, Colorado Springs, was a well-timed acknowledgment that Swartz was appreciated beyond the state of Arizona. As she scrutinized her work, exhibited beside that of other accomplished artists, she could see clearly for the first time that it was a record of growth. She detected distinct transformations and realized that, in her use of fire, she had begun an even more important one. This show gave her a vital boost of self-confidence just as she was working out plans for her one-artist exhibition in Scottsdale.

During the Scottsdale exhibition's initial planning phase, Swartz attended a lecture given by the respected art critic Lucy Lippard on the subject of women artists who work with ritual. Lippard's discussion gave Swartz the idea of contacting other artists who had also been working with fire, and including documentation of their discoveries in her exhibition. For the first time, Swartz gained insight into the synchronistic nature of

her evolution as a seeker, which linked her to others on a similar path. As the year unfolded, Swartz synthesized her private life, her artistic effort, and her spiritual development into a whole. In eighteen months, she first imagined and then created the major show, "Inquiry Into Fire," based on the use of fire as an art form. It was the largest exhibition she had attempted, and Swartz wanted it to include more than her own work. At lectures and other meetings, she met with artists who worked in film and dance and discussed her proposal with them. Soon, the plans for the opening enlarged into a happening. In hours not devoted to painting, Swartz was especially involved with the design and content of the show's catalog.

Swartz reached out to the community for assistance with this show. She prepared a proposal of her plans and took it to the Arizona Commission on the Arts and Humanities, the Phoenix Jewish Community Center, and the City of Scottsdale to request funding support. When her proposal was accepted by these groups, she set about painting, using fire as a component of the art.

In preparation for "Inquiry Into Fire," Swartz made a logical, though rapid, development from a tentative command over the element to a forceful domination of it. Her *Cabala Series* progressed from the first transition piece that Swartz describes as "a tender use of fire, still a lyrical abstraction," to the second piece in the series, now owned by the Jewish Museum of New York. Swartz used fire to draw on sheets of mutilated paper, creating works of delicate tones reminiscent of her *Smoke Imagery* experiments. "I was capturing the flow of smoke on paper just as I formerly captured the flow of water and color."

In addition to layering, *Cabala #9* has the added elegance of metal leaf. The three parts resemble pages from an ancient manuscript, aligned in scroll-like fashion. The horizontal banding is repeated, with slight variations, on each of the "pages." (These ideas are to be carried forward for several years and will eventually reappear in her *Illuminated Manuscript Series*.)

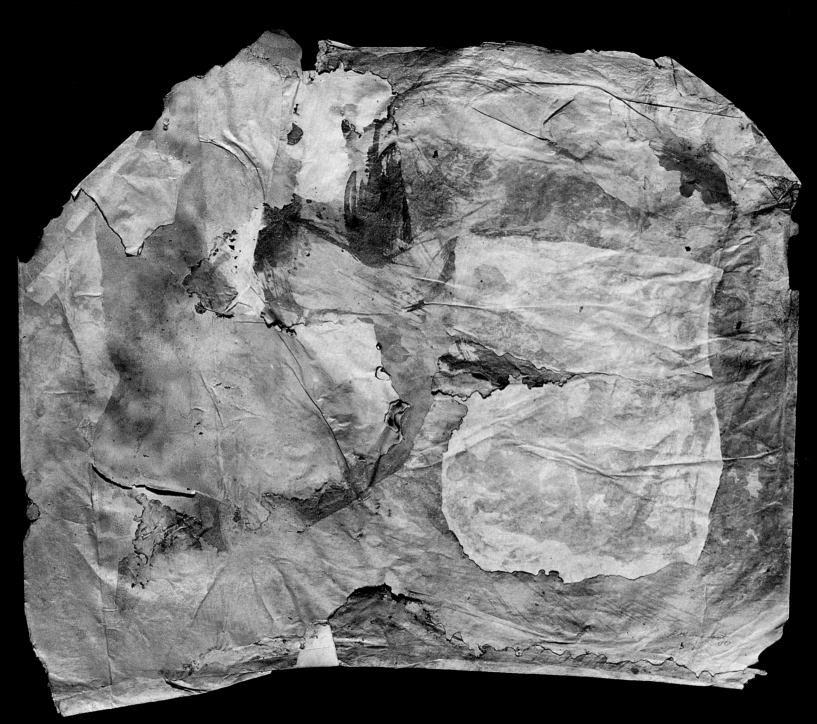

1977
Cabala Series #2
fire, mixed media on rice paper
43 x 53 inches

Swartz did not intend to imply by the title *Cabala* that she was studying the Kabbalah (there are many acceptable spellings of the word—Kabbalah is most often used), but she was attracted to it. The conveyor of hidden wisdom whose origin is lost in the distant past, the Kabbalah is often referred to as mysterious, ancient, and poetic. With modern materials, Swartz evoked these qualities, creating a remnant of the Biblical age.

During her preparation for the "Inquiry Into Fire" exhibition, Swartz moved from the *Cabala Series* through a *Fabric Transformation Series.* These were collages in which ragged fragments of ordinary cloth, enriched with paint, were placed behind openings in lightweight Oriental papers that were reshaped by tearing the edges in a freeform way. In *Fabric Transformation #8,* the whole arrangement was set against a torn sheet of deep pink. There is a paradoxical beauty of coloration in this series.

Ideas followed each other quickly during this time. *Mica Transformation #3* is the direct opposite of the *Fabric Transformation Series,* in that glamorous materials have been transformed by tearing and collaging them into an iridescent whole. Silver tea paper was mutilated, burned, and then collaged to torn rice paper. Large mica chips formed a pattern of light-catching squares that moved across the painting. Glimmerings of metal and mica blended into material suggestive of old silk—perhaps a scrap of an ancient robe. Having worked her way through these early inquiries, Swartz was in an adventurous state of mind. She saw painting possibilities everywhere.

Swartz retained an image of the Dead Sea Scrolls that she had seen in Israel at the Shrine of the Book. The thought of these brittle relics remained with her as a positive, reassuring antidote to the lingering threat of violent death which she inferred from other aspects of Israel, such as the Memorial to the Holocaust. She wanted to make a tribute to them in some way, and she concentrated her imagination on this effort. The development of her fire work was moving rapidly when she began working on long (approximately nine feet) rolls of two-hundred-pound rag watercolor paper. This

It was . . . Planck who said that the development of theoretical physics has led to the formulation of the principle of physical causality that is explicitly teleological in character. In other words, physics has proved that there is a definite purpose behind the causes of the material world, which is something that the ancient Kabbalists knew long before the advent of physics.

MIGENE GONZALEZ-WIPPLER

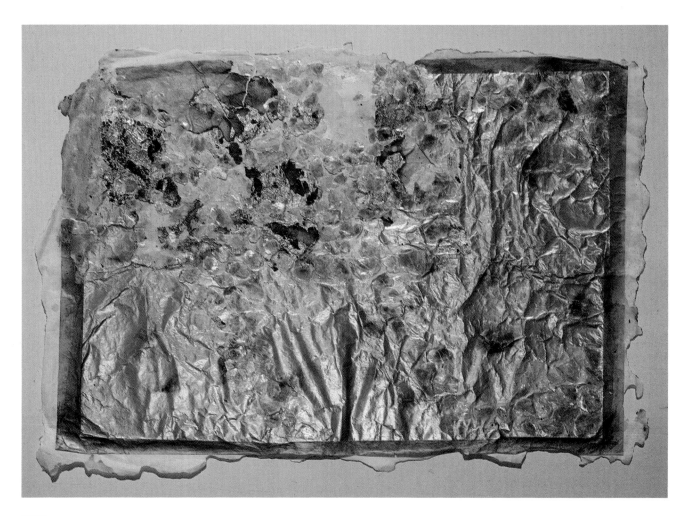

1977
Mica Transformation #3
mica, fire, mixed media, silver leaf, ash on handmade paper
23 x 32 inches

satisfied her desire to paint on a larger format and also gave her the means to create a scroll. Now, instead of a group of related panels hung together, her work stretched out as a single unit. The scrolls were vastly different in emotional timbre and in art quality from the *Cabala Series.*

The *Cabala Series* was a transition from flowing color on single sheets of paper to ritualistic layerings of mutilated papers. These paintings were ethereal, meant to evoke the feeling of a hermetic text found in worn pages, fragile with age. The *Torah Scroll Series* paid homage to the tangible, human record of the Jewish people. It was literally and figuratively an earthier and more dramatic series than the *Cabala,* and included a new step in Swartz's process/ritual: a layer of earth dug from the mountains near her home. This soil added both color and texture to her work. Because the paper was cumbersome to paint on in the studio, and because she needed access to earth, Swartz began working outdoors.

The creative process/ritual Swartz evolved in 1976–1977 echoes Land's paradigm of ordering, disordering, and reordering. For the artist, this was a birth, death, rebirth ritual, privately and intuitively conceived. It successfully led her to a higher level of creativity and the invention of new material, something original, that resulted from a fusion of fire, layers of paper, earth, and pigment.

The physicality of her process/ritual, its reality as active painting and expressive dance, is important to an understanding of the work Swartz created. Moving rhythmically around the paper, she shoveled ordinary soil onto the charred sheet and added a generous amount of rhoplex, a liquid acrylic bonding material, to hold the earth in place. Then, she poured on washes of acrylic paint. She repeated the process on other papers, some as lightweight as rice paper, and bonded them to the original layer. Through burned holes and transparent layers, glimpses of the first sheet are visible. The work was exposed to the extreme changes of temperature in the desert, another way Swartz enlisted the elements into the

White paper is rolled out and made ready for the artist's unique process/ritual.

Ice is randomly placed on the paper's surface, and the artist begins a series of mutilations.

The mutilated paper is set ablaze.

After the flames are extinguished, mixed media are applied.

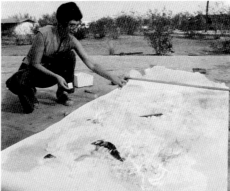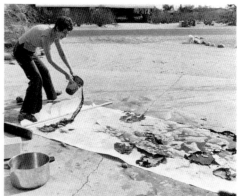

Earth is scattered across the mutilated, burned, painted paper and the entire piece is exposed to the elements.

The artist gazes through an opening in the finished work, now richly textured and colored, three-dimensional art.

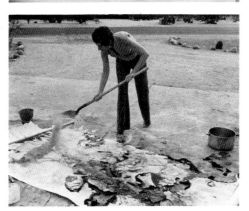

68

1977
Torah Scroll Series #9
fire, earth, mixed media on paper
40 x 82 inches

service of her work. Some of the *Torah Scrolls* were so warped that they had the appearance of a bas-relief. At the installation of "Inquiry Into Fire," several scrolls were hung as freeform objects. Most of the other scrolls were displayed in plexiglass boxes with contrasting black cloth backgrounds. The frames had a dramatic effect that enhanced the texture and color in the pieces.

As Swartz expanded her working scale, she developed courage in her art and in herself, as well. Fire is a dangerous element, directly threatening and destructive, but she grew familiar with its ways. She allowed it to burn freely and then extinguished it when she felt she had achieved the desired effect. Her creativity involved pitting herself against possible accidents. Continual exposure to risk had a positive effect on her feeling of self-worth; she felt protected from small fears that had formerly hampered her.

"Inquiry Into Fire" was a landmark accomplishment, a coordination of creative effort led by Swartz with almost visionary imagination and organization. The opening at the Scottsdale Center for the Arts in February 1978 was a remarkably well-conceived event. In addition to exhibiting her own new work, Swartz also provided an opportunity for the performance of an especially choreographed dance that centered on the same theme.

Stephen Seemayer created *Tri-Chamber,* an installation of burning propane in a triangular room. On February 14, in conjunction with the exhibition, Geny Dignac set small fires to create a flaming shape on the desert surrounding Scottsdale. Her "fire gesture" was witnessed and photographed, adding an extra dimension to the exhibition. In the art center, there was extensive documentation: prints of fire-pieces by other artists, slides, tapes, graphic displays that amplified the concept of fire and related it to the Phoenix. There is little doubt that Swartz performed an intellectual as well as an aesthetic feat in conceptualizing "Inquiry Into Fire," a feat few artists would be able or willing to do. The energy, organizational capability, generosity in including other artists' work, and intellectual scope that Swartz brought to the project are rare qualities. In effect, she was her own historian and placed herself on the leading edge of exploratory contemporary artists.

Melinda Wortz summarized Swartz's achievement in an article written for the "Inquiry Into Fire" catalog:

> . . . although Beth Ames Swartz has been working in isolation for twenty years, she now finds herself a participant in an international community of artists engaged in similar pursuits. Nonetheless, her art remains intensely personal in its genesis. . . .

Wortz also described the beauty of the work as "unabashedly lyrical" and went on to conclude, "The layering of materials and colors is done with a sensitivity for their inherent elegance."

This sensitivity was also a factor in the remarkable manifestation of mutualism that Swartz generated in "Inquiry Into Fire." The exhibition had an enduring result in her change of stature from a regionally recognized artist to one of growing national acclaim. She was chosen as one of four

1977
Torah Scroll Series #4
fire, earth, sunlight, mixed media on layered paper
44 x 112 inches

Arizona artists to be in the First Western States Biennial Exhibition, which toured until 1980. The Western States Biennial was a forceful voice for the diversity of creativity found in the United States. Coverage of the show was given by many journals, and April Kingsley, writing in *Newsweek,* described Swartz as one of Georgia O'Keeffe's "most accomplished successors." Reviewers for *Soho News* and *Smithsonian Magazine* praised her originality. A film made for educational television focused on six artists in the exhibition, including Beth Ames Swartz. Her segment was long enough for viewers to observe her ritual process as she spoke of her purpose and aesthetic.

After a major achievement, there is often a feeling of let-down, a sinking depression through which a creative person must pass. Swartz had such a reaction to the completion of "Inquiry Into Fire," a project that had absorbed nearly two years of her life. As part of this restorative process, she went alone to Houston in the spring of 1978 to view a widely heralded Cézanne exhibition. Instinctively, she knew she did not want to miss such an important show of an artist whose work she greatly admired. The fortuitous experience had repercussions in her art.

Cézanne so often painted the forms of Mont Sainte-Victoire, the Chateau Noir, and the forested park surrounding it that he is virtually identified with these places. The more she looked at his paintings, the more Swartz wondered, "Where is *my* place?" At least one of her connections must be with Israel, she felt, where she was first inspired to use fire. At the Cézanne exhibit, the thought was planted that one day she would return to Israel.

While in Houston, Swartz also visited the Rothko Chapel and was profoundly moved by it. "The feeling of wanting to create a spiritual atmosphere or environment came to me, I think, in the Rothko Chapel." She returned to Scottsdale refreshed and ready to reenter her studio.

By the fall of 1978, "Inquiry Into Fire" had received attention in the national press. Critic Barbara Rose saw the catalog for the show and wrote to Swartz with both encouragement and advice. She recommended that

1980
Red Rock—Sedona #1
fire, earth, sunlight, mixed media on layered paper
40 x 60 inches

*. . . And all shall be well and
All manner of thing shall be well
When the tongues of flame are in-folded
Into the crowned knot of fire
And the fire and the rose are one.*

T. S. ELIOT

the artist attempt to schedule a New York exhibition. "I felt I owed it to the work to take Rose's advice and try for the show. I felt I had a responsibility to show courage; my art had courage and power—I had to have those qualities, too." When Swartz returned to Paradise Valley after three weeks in New York, a one-person show of her work was scheduled to open at the new Frank Marino Gallery in February 1979.

Swartz felt that she was at another point of transformation in her work. She wanted to add something to her process/ritual, and go further in the development of her fire work.

The deep red color of northeastern Arizona triggered the next change in Swartz's art. She began a series based on the Sedona–Red Rock area that included earth of the region in her layering. The idea began simply as an innovation in technique, but it grew into an altered philosophical relationship to her work. Her tangible connection with the earth broadened as she worked on the *Sedona Series.*

Swartz added a distinct new step to her process/ritual in creating the *Sedona Series.* After painting a scroll, she ripped the entire work into large fragments and painted every torn edge along its back surface to eliminate rawness. She then created a mosaic of fragments against black backgrounds which showed through as cracks of strongly defined negative space. In their final form, these mosaics gleamed with color and texture. They are beautiful objects that appear to have been torn from a canyon wall, just at sundown.

In each stage of her creative development, Swartz painted works that are beautiful. Beautiful in this instance is not a synonym for pretty, but rather a reference to the felicitous arrangement of formal elements in a work of art. The aesthetic value of beauty, which has come into question in this century, does not negate the appreciation for it felt by most people.

1979
Sedona Series #21
fire, earth, sunlight, mixed media on layered paper
27¼ x 52¼ inches

1978
Sedona Series #6
fire, earth, sunlight, mixed media on layered paper
29 x 36 inches

Swartz's large, richly glowing paintings are genuinely creative and lastingly beautiful.

In 1979, Swartz was invited to spend the month of August as artist-in-residence at the Volcano Art Center on the island of Hawaii and to teach a workshop; her family shared her working vacation. She demonstrated her process/ritual and, during her free time, collected some of the island's famous black sand. This material was later used in a series of fragmented works titled *Black Sand Beach Series,* which she completed after her return to Arizona.

The richness of surface texture and color that was evident in the *Torah Scrolls* and *Sedona Series* is brought even further toward luxurious elegance in the *Black Sand Beach* paintings. Swartz also did a *Green Sand Beach Series;* hiking into a remote cove, she gathered some of the chartreuse sand and bundled it up to take back with her to Arizona.

In her beach paintings, Swartz began mixing her acrylic paints with bronzing powders so that every touch of color had its own radiance. The transparency and fragility of her *Cabala* paintings were missing from these encrusted, dense pieces whose effect is of bejeweled, gilded relics, recovered from a lost treasure trove.

In a continuation of the process/ritual related to a site, Swartz did the *Monument Valley Series.* From the *Sedona Series* through this *Monument Valley Series,* fragmentation and the negative cracks between major parts were vital components of elegantly gleaming works.

The culmination of Swartz's work of this period was a 1980 exhibition she called "Israel Revisited," a complex synthesis woven from many threads.

As a result of her extensive work with earth, the desire she first felt in Houston to return to Israel suddenly seemed possible to fulfill. She drew up a prospectus for a proposed exhibition of work to be painted with earth from Israel; her plan included a tour of the country in order to paint at

1979
Black Sand Beach #12
fire, sand, sunlight, mixed media on paper
24 x 40 inches

1979
Green Sand Beach #1
fire, sand, sunlight, mixed media on layered paper
40 x 65 inches

1980
Monument Valley #12
fire, earth, sunlight, mixed media on layered paper
24 x 36 inches

sacred sites. The Jewish Museum of New York and six other museums scheduled her proposed show. Other patrons, when advised of the project, were eager to sponsor her work. In less than a week, eighteen had pre-purchased paintings to fund Swartz's trip. Later, she also received grants from the Memorial Foundation for Jewish Culture and the United States International Communication Agency to assist with expenses.

The question of which sites she would visit in Israel immediately arose, and to answer it, Swartz studied Biblical history. She and a research assistant searched for accounts related to specific areas in the Holy Land. The hero of Bible stories seemed always to be a patriarch or prophet, but Swartz "felt the need to find, acknowledge, and honor women," so she turned instead to heroines of the Bible, women who had been effective in causing change. Accompanying this study and as a natural outgrowth of her interest in unseen coincidences and the great philosophical questions of birth, life, death, and rebirth, Swartz was attracted to the Kabbalah and began a systematic study of it. By taking this step, she precipitated the most dramatic transformation she had yet experienced in both her art and her view of the cosmos.

Kabbalah is a Hebrew word meaning "doctrine received by tradition." It is thought that when Moses authored the first five books of the Bible, he hid a key to arcane mysteries within the text. The Kabbalah is a system whereby these books are studied to penetrate their esoteric content. The nature of an infinite God is related in the Kabbalah to the finite universe through four worlds, descending from All That Is to the objective world of earth. There are Christian as well as Jewish Kabbalists; however, the ancient lore retained in the scriptures is far older than Judaism and may have originated prior to the Egyptian hermetic tradition that predates the Bible. In modern times, the Masons and the Rosicrucians are among the Christian repositories for and teachers of ancient wisdom.

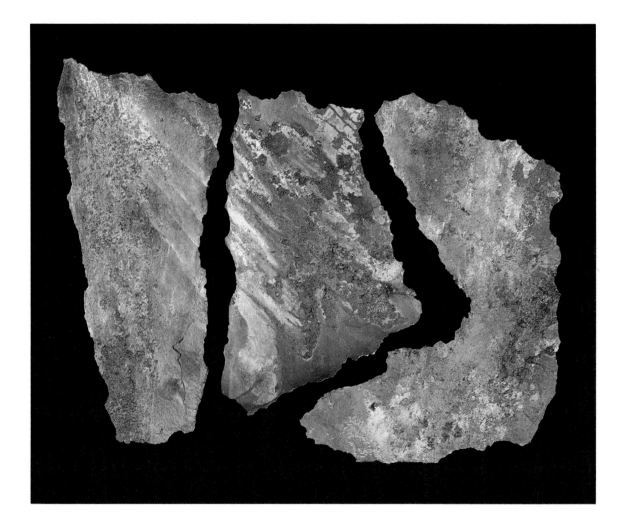

1978
Three Fragments
fire, earth, sunlight, mixed media on layered paper
22 x 30 inches

Judaic Kabbalistic scholars flourished in southern France during the twelfth century, and by the sixteenth century, Kabbalist mystics had founded a center in the city of Safed in northern Israel. The tradition of Judaic mysticism continues to the present day. Only mature persons are to study the Kabbalah, and by Jewish tradition, men alone were qualified for such learning; this restriction, however, has been relaxed in recent years.

The Tree of Life is the magnificent Kabbalistic paradigm of the order of the four worlds. The earthly world is that of action; the higher worlds are formation, creation, and emanation. The relationship of God and mankind in the Tree of Life is represented by numerous graphic devices: a tree, sometimes shown upside down; a diamond-shaped network; a ladder; two pillars of an arched doorway; a mandala enclosing a maze; a solar system of concentric circles; or Adam-Kadmon, a primordial androgynous man. The Tree of Life superimposed on Adam's body joins the human microcosm to the macrocosm. The lesser and greater follow the same pattern of creation and contain the same Divine Attributes: each is known as a sefirah (sefirot, plural form). These ten sefirot mark the intersections of the ladderlike model. The sefirot, from the lowest to the highest, are Malkuth, severity; Yesod, foundation; Hod, intelligence; Netsach, victory or eternity; Tifereth, beauty or balance; Geburah, severity or righteous drawing of the sword; Chesed, mercy; Binah, understanding; Hokomah, wisdom; Kether, the source of light or radiance. Understanding, intelligence, and severity are considered feminine attributes and are opposed by the three masculine attributes of wisdom, mercy, and victory. Kether is androgynous, as are beauty, foundation, and kingdom, and the eleventh attribute, knowledge, which some Jewish scholars place at the juncture between the uppermost and second highest worlds. Knowledge in Hebrew is Daath, an unrevealed sefirah.

As does Jungian psychology, the Kabbalah ascribes qualities of both genders to a single person, man or woman. Jung proposed that within the

male ego there is a shadow *anima* or womanly alter-ego, while there is an *animus* or masculine alter-ego within the female. A basic premise of Kabbalistic thinking is that the unknown can be described by means of the known. Because humankind includes both man and woman, and Scripture declares that man is made in God's image, Kabbalists theorize that God must be androgynous. As a consequence, they pay honor to the Shekhinah, or feminine aspect of God.

Kabbalists speak of the Lightning Flash of Divine Energy that emanates from Kether and streaks through all the higher worlds to illuminate the earth. Swartz had an intimation of the sudden nature of an illuminating inspiration when she connected her proposed trip to Holy Sites in Israel with the Tree of Life and great women of the Bible. The character of her project deepened into a quest, a spiritual journey to rediscover the Shekhinah.

In the long Judeo-Christian tradition, God has been portrayed as masculine. Swartz believes in a balanced image of God for the good of men as well as of women. Her *Ten Sites Series,* part of the "Israel Revisited" exhibition, is a positive contribution to such an image. Swartz correlated each site with an honored female figure from religious history and connected these to a sefirah that had meaning in the woman's story. She further adapted the Kabbalist system of linking a color and a number to each sefirah. By identifying with the Kabbalah, Swartz retained the integrity of her philosophical position and also found a suitable place within her religious heritage. All four worlds of the Kabbalah can be experienced simultaneously, provided one is aware of that possibility. Swartz is aware of it. In an unconscious form, that awareness is what made her feel different from others in childhood; it is the source of her creativity.

Her 1970 trip by raft on the Colorado River set in motion her sense of being connected with the earth. The identification of her own womanliness activated her paintings of the early seventies with a suggestion of two

levels, the naturalistic overlaid with an esoteric message. Fire—cauterizer and cleanser—allowed her to express ineffable thoughts on a higher level of creativity than watercolors. With fire, she explored the possibility that some aspect of life, like the Phoenix, rises transformed from the ashes of death. Her *Ten Sites Series,* still within this evolving pattern, was conceptually structured as the Tree of Life. Taken together, the ten symbols expressed the unity that underlies the Kabbalah's phrase "all is one." Idea and expression developed synchronistically in Swartz's art and they, too, are one.

As Swartz prepared for her trip to Israel, she was also working with her daughter Julianne preparing her for her spring bat mitzvah. They wanted to have a personalized service, and so they created part of Julianne's bat mitzvah recitation in accordance with modern practice. Like her male counterparts, Julianne needed to learn to read and speak Hebrew as part of the ceremony. To Swartz, this was a connection, another sense of unity linking her daughter's approach to womanhood and her own search for the Shekhinah. She decided to take Julianne to Israel.

With trepidation and exultation, Swartz and her daughter arrived in Tel Aviv. All necessary supplies and equipment for the undertaking were either shipped ahead or went with them on the plane. While Julianne remained with relatives in the city, Swartz set about coordinating the final details of her project.

Synchronicity was part of her first hours in Israel. Meeting a Kabbalist rabbi, she was fortunate that he desired to go over her plans with her. He approved of the special prayers and ritual Swartz had prepared to use before painting at each chosen site, and was surprised by her sound scholarship. This acknowledgment of her work was especially welcome to Swartz; it provided her with an official sanction of a sort.

Swartz has a strong sense of community and seems to create one wherever she goes. By chance—which Swartz believed to be part of an

The artist at the site of Tiberius, in northern Israel.
(from the "Israel Revisited" catalog)

overall blessing for her project—she met two young Israeli women, Yael Rosen and Rachel Lowinger, students of the Kabbalah. She established with them an immediate sense of shared experience. With their camera and car, they joined Swartz on her expedition. They understood that the project had religious significance and they provided a prayer group in support of her ritual. Denise Urdang, an American woman who chanced to hear about the plans for "Israel Revisited" from Swartz in a New York art gallery, was also in Israel as a member of the team. She learned to use a video camera in order to assist in the work.

The four women shared a benign and deeply emotional experience. The weather was fine. The wildflowers blooming in the desert reminded Swartz of Arizona and reinforced the connection she felt with both land-scapes, a similarity she now believed was meaningful. The antipathy Swartz felt for the Arizona desert in 1959 had been transformed into an attraction to its mysterious beauty, a primary inner motivation for her distinctive art. She knew she had to learn to trust Israel, too. On her first visit, it had seem saturated with the darkness of death, but when she returned, a different aspect presented itself to her. She saw the eternal beauty of its desert location as related to Arizona, and felt she belonged in both places.

The group encountered no violence, although shortly after they left Hebron a terrorist attack occurred there. A number of hours were spent at each site. Painting and layering took at least two hours, and drying the work, two hours more. At the Cave of Machpelah, where Rebekah is buried, and at Rachel's tomb in Bethlehem, Beth was prevented from painting because there were crowds of weeping mourners; her own reactions to the sites were also too emotional. To her, one of the most moving aspects of the trip was being on sacred ground in Israel. Wherever possible, she fulfilled her plan to consecrate a large circle of earth with prayer and to paint the long scrolls within the boundaries of this circle. These ten

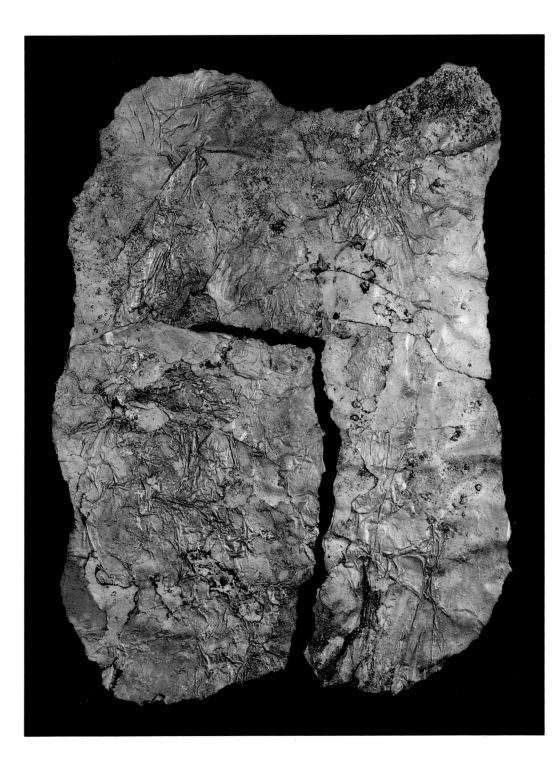

1980
Tiberius #1 Honoring Dona Gracia
(Tifereth, 6, Balance, Gold)
fire, earth, sunlight, mixed media
 on layered paper
51 x 38 inches

scrolls, approximately ten feet each in length, were shipped by the artist to Scottsdale. While in Israel, she took the works through two complete cycles of ordering, disordering, and reordering. She sent home small labeled bags of soil from each site to use in completing the work when she returned to Arizona.

After her return, Beth wanted to discuss her experiences and did so with her long-time women's support group.

"I shared my feelings with the group. I felt immobilized for a month after returning from Israel—the emotional impact of the trip was so strong that I felt inadequate to the task of translating aesthetically what I had experienced emotionally. It seemed too great a responsibility. But it was too late to turn back; I had to try. The group gave me their support and I went back to the studio and started to work."

From further study of Hebrew, begun in early preparation for Jonathan's bar mitzvah, Swartz added another layer to her process/ritual. Once again, she broke her scrolls into fragments but went beyond simple mosaic by building the fragments into larger forms directly related in a symbolic way to the ten heroines, sefirot, and sites. To shape the pieces into one form, she backed them with rice paper. In some of the paintings, she formed letters of the Hebrew alphabet as the shape of the negative areas between major segments. Those who know Hebrew may recognize these as hidden letters, but Swartz made them obscure deliberately.

The ten major shapes of these tributes to Biblical women are like totems, or mandalas, with the power of private language. Their forms relate to each site far more openly and figuratively than Swartz's earlier earth pieces. There was a sculptural, space-filling quality to the *Ten Sites* paintings; the intricate construction and subtle meaning in the ten paintings represented another transformation in Swartz's art. The fragments were overlapped, built up and allowed to overhang one another. Again,

1980
Bethlehem #1 Honoring Rachel (Chesed, 4, Mercy, Blue)
fire, earth, sunlight, mixed media on layered paper
49 x 44 inches

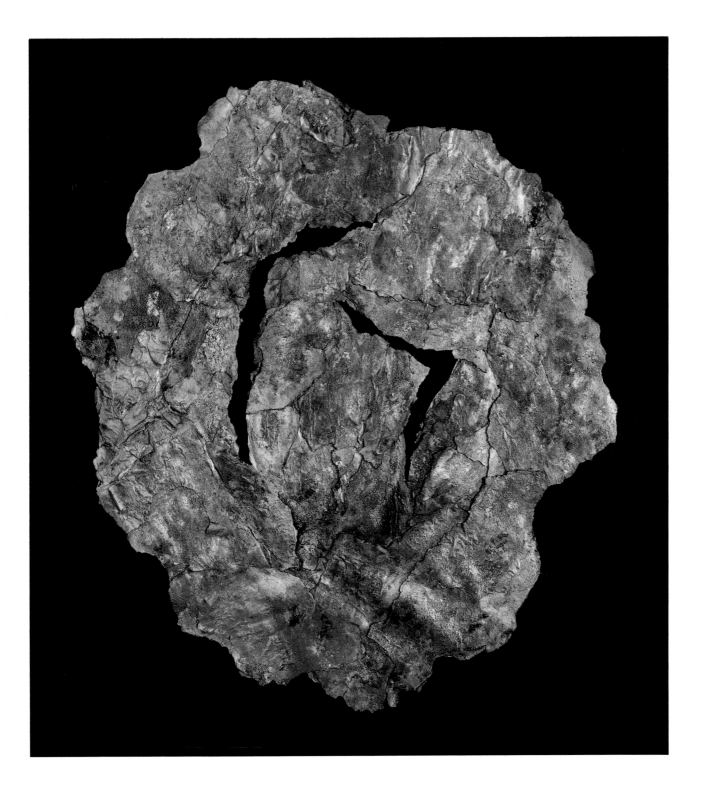

every edge was finished, front and back. The viewer looked into caves of darkness between layers.

In his introduction to the catalog of "Israel Revisited," Harry Rand describes the unique aesthetic quality of the work:

> Rooted in a tradition of intelligent inquiry about formal properties and materials, both within the Modernist tradition and others, Swartz's work is distinguished by its ravishing wealth of effects. The beauty of her art is striven for and not the by-product of other areas of investigation. Harmonized, heightened, and amplified, an elaborate, forceful, and above all, a complex experience is presented . . . hue is a principal channel of expression and a way to identify individual thematic strands.

Of particular interest in all the *Ten Sites* work is the esoteric code Swartz created to interlock Kabbalistic references with those of the Tree of Life and actual places in Israel. It is hidden within the work, and is magically conceptualized; it can be known only to the initiated. For example, Rebekah is connected with the number three and the sefirah Binah, or wisdom. The third letter in the Hebrew alphabet is Gimel, and it also stands for the number three. Gimel appears as a cypher within the open spaces of *The Cave of Machpelah,* whose shape forms a butterfly. It is dedicated to Rebekah. Thus, "Israel Revisited" is more than an exhibition of works on paper. It is a revelation of intellectual and mystic linkages.

In a brilliant, glowing redness, *The Red Sea* projects forward to catch light. It is a tribute to Miriam and demonstrates a shape not previously seen in the artist's work. In previous paintings, Swartz consciously resisted feminist imagery, but now allowed this uterine-ovarian shape to manifest itself. The shape speaks to the viewer in a resonant voice, seeming to say,

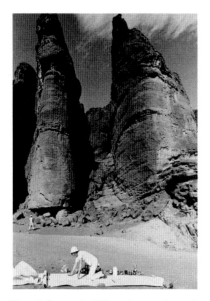

At King Solomon's Pillars in southern Israel, Swartz honored the Queen of Sheba, a woman renowned for her wisdom. (from the "Israel Revisited" catalog)

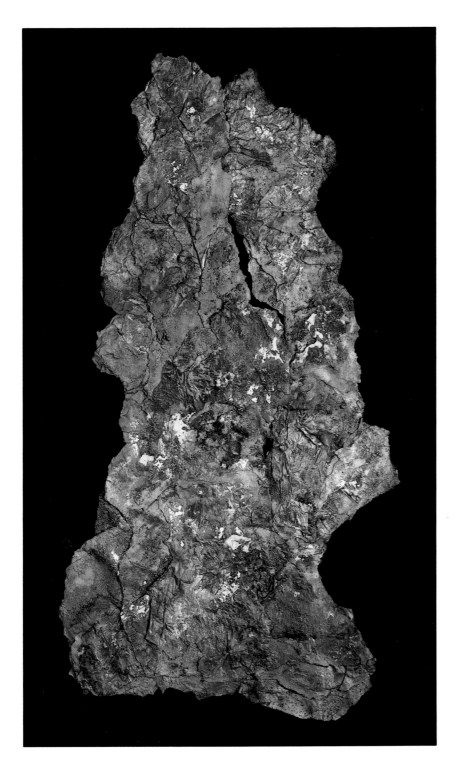

1980
*Solomon's Pillars #1 Honoring the Queen of Sheba
(Hokomah, 2, Wisdom, Silver)*
fire, earth, sunlight, mixed media on layered paper
59½ x 32½ inches

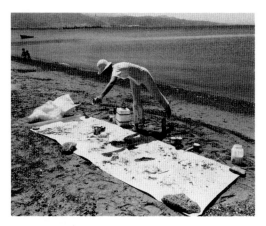

The Red Sea her backdrop, Swartz concentrates on the work honoring Miriam, a prophet and leader of the Israelites. (from the "Israel Revisited" catalog)

"I am woman. I am an essence. I am part of All That Is, a source, the Shekhinah."

The Red Sea is a complex trifoil, whose irregularity of form can be read as a unity of male-female organs. In contrast to the upward-rising pyramid, or pillar—always reaching outward from the earth—Swartz has created an enclosure, an Ark of the Covenant or indwelling shelter. In *The Red Sea,* she suggests that nourishment and truth are on the earthly plane, that God and the Goddess are found within. To enclose is to bind opposites together. *The Red Sea* can be considered a glorification of what it means to be fully human. From clearly physical references, Swartz has created a majestic symbol for the metaphysics of unity.

In a passage that can be related to Swartz's quest, the famed Kabbalist scholar Gershom Scholem has written of the Shekhinah:

> The reunion of God and His Shekhinah constitutes the meaning of redemption. In this state, again seen in purely mythical terms, the masculine and feminine are carried back to their original unity, and in this uninterrupted union of the two the powers of generation will once again flow unimpeded through all the worlds.

Before her *Ten Sites Series* was exhibited, Swartz moved on to her related *Buried Scroll Series.* Once more, she created a new version of her process/ritual to accommodate an intuited vision of a connection with Israel.

She unrolled a long piece of rice paper and painted it, silver on the front, gold on the back. Then she burned all the edges before folding them forward, giving the impression of a framework of gold around the silver side. On horizontal lines the length of the scroll, she printed the name of

1980
Red Sea #1 Honoring Miriam
(Hod, 8, Intelligence, Orange)
fire, earth, sunlight, mixed media on layered paper
41 x 47 inches

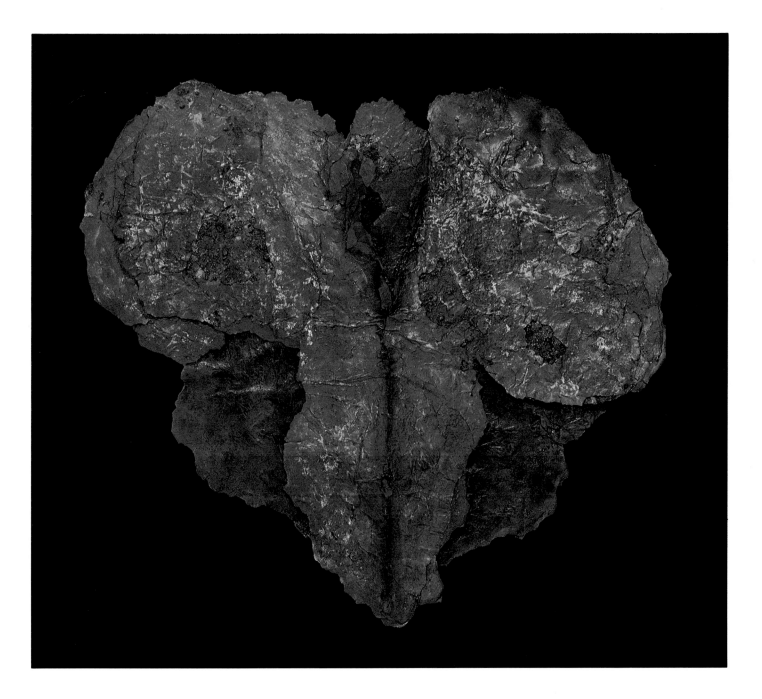

Jerusalem, one of the holiest cities of Judaism, Christianity, and Islam, was the site of Swartz's homage to Queen Alexandra and the prophet, Huldah.

a Biblical heroine over and over again, covering the sheet. She then overlaid several lines of printing with strips of rice paper that had been singed along all sides. The strips alternated with patches of earth from the appropriate Israeli site.

At this stage, the scroll had a clothlike quality. In size, it appeared to be a long scarf, or a freshly made piece of hand-painted silk. Swartz then disordered the piece by crumpling and burying it for a month. Ritually exhumed and unfurled, it took on a weathered, flowering shape, more three-dimensional than in its original state. Also displayed in the "Israel Revisited" exhibition, the *Buried Scroll Series* was a compatible foil for the imposingly rich *Ten Sites* pieces.

John Perreault, in *The Soho News,* October 13, 1981, wrote with insight about Swartz's dual exhibitions on view in New York at the Jewish Museum and at Frank Marino's gallery. He confessed to a love of the desert and earthy sites and to the belief that Swartz "taps those energies." Particularly astute in detailing the various strands that Swartz brought to "Israel Revisited," he commented: "Several systems of meaning converge: abstract-expressionist, gesture-process modes of making art . . . new regionalism, feminism, and Jewish mysticism. There is also an alchemical, magical layer—an influence of the 'secrets' of the Cabala—that leaves one amazed that paper can be transformed into luxurious and seemingly timeless abstractions." Perreault clearly responded to the multiple references in the work, but he concluded, "All of this contributes to the impact of the art, but none of it would be worth mentioning if the pieces themselves were not strong in their own right. . . ."

The strength perceived by Perreault in Swartz's work was also reflected in the *Illuminated Manuscript Series,* another expression of Swartz's fascination with Hebrew letters. These letters have a deeper significance than simply as elements of a language. As Migene Gonzalez-Wippler writes in *Kabbalah for the Modern World:*

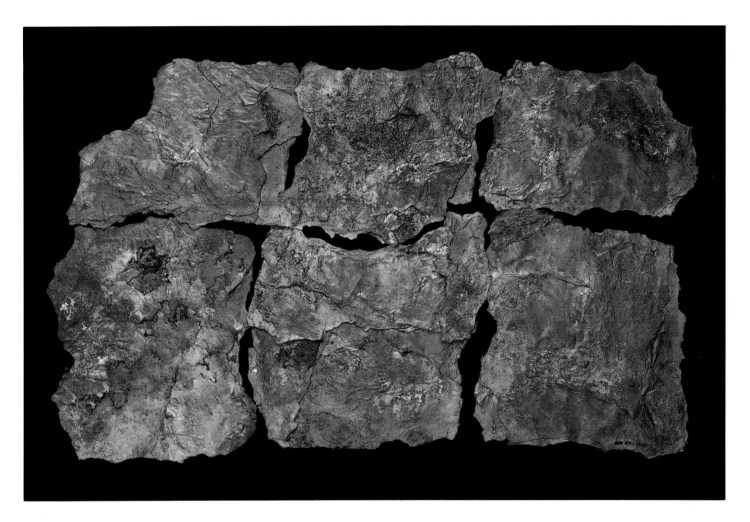

1980
***Jerusalem #1 Honoring Queen Alexandra and
the Prophet Huldah (Malkuth, 10, Kingdom, Russet)***
fire, earth, sunlight, mixed media on layered paper
32½ x 52½ inches

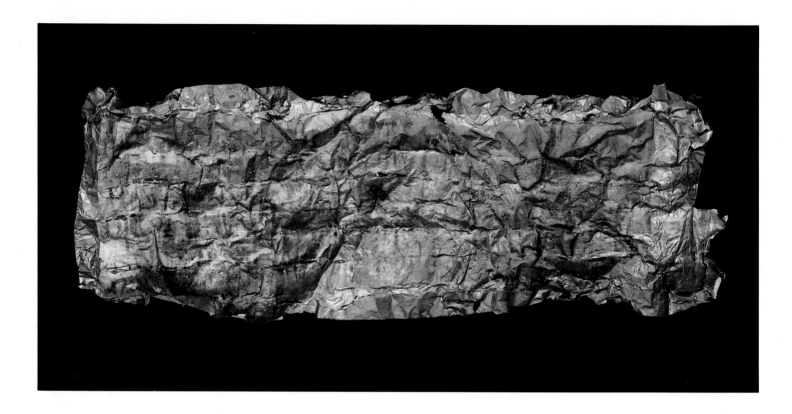

1980
Buried Scroll #1
fire, earth, sunlight, mixed media on layered paper
14½ x 42 x 2 inches

The Kabbalah teaches that God created the universe by means of the Hebrew alphabet. The twenty-two letters that form the alphabet are really twenty-two different states of consciousness of the cosmic energy and are the essence of all that exists. Although they represent numbers, symbols, and ideas, they cannot be easily classified because they are virtually all the things they designate.

The *Illuminated Manuscript Series* employed an intriguing combination of Hebraic letters and ritual. On silvered rice paper (tea paper), Swartz began by painting a rectangular grid and, into the grid, she painted the twenty-two Hebrew letters. She burned the paper lightly, giving a melted appearance to wherever the torch flame touched. Strips of already-singed rice paper were glued over the grid so that the letters were partially hidden, then the entire work was set aflame. Together with the *Buried Scroll Series*, the *Illuminated Manuscript Series* offers a contrast that is more cerebral and less emotional than the *Ten Sites* masterworks.

In the *Buried Scroll Series* and the *Illuminated Manuscript Series*, Swartz directly addressed the problem of meaningful content. She intended to communicate, via these pieces, with those who have the knowledge to interpret what she housed within the art. There was both an aesthetic dimension as well as an informational one. Her technique of incorporating Hebraic lettering in a cryptic manner linked her with artists far distant in time: New Kingdom Egyptian fresco painters, Mayan calendar-makers, and T'ang Dynasty Chinese calligraphers, too, created what Fred Gettings terms "sigils" in his *Dictionary of Occult, Hermetic and Alchemical Sigils.*

More than a symbol or glyph, a sigil is a graphic device with precise meaning for initiates. Gettings quotes H. P. Blavatsky, who wrote in 1888 in *The Secret Doctrine: The Synthesis of Science, Religion and Philosophy,*

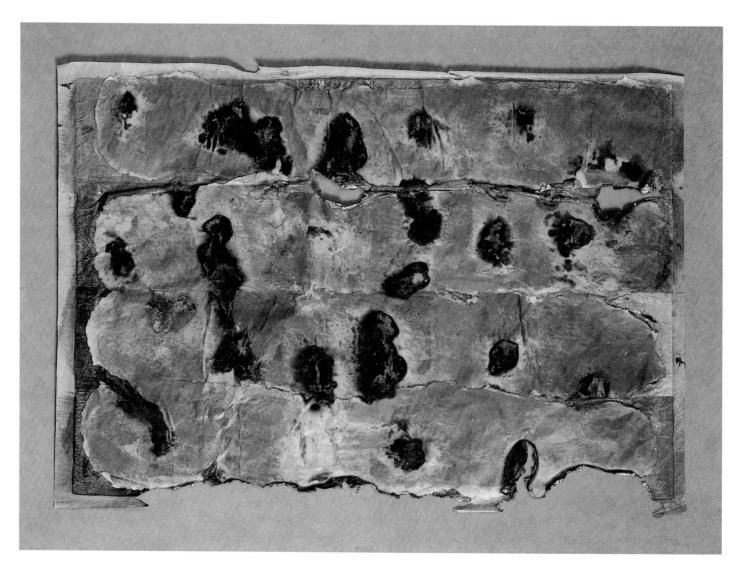

1980
Illuminated Manuscript #1
fire, earth, sunlight, mixed media on layered paper
21 x 31 inches

"A symbol is ever, to him who has eyes for it, some dimmer or clearer revelation of the God-like." Swartz used the Hebraic alphabet as a Kabbalistic sigil in the *Illuminated Manuscript Series,* attempting to reach yet another level of communication and connection.

The rumpled forms of the exhumed *Buried Scroll Series* led Swartz to take another innovative step in 1981. After learning to make paper of imported Chinese raw flax fibers from Alexandra Soteriou at her Atelier Du Livre in New Milford, New Jersey, Swartz created the *Rock Series.* The handmade raw flax paper, an earthy, textured material, was similar in feeling to the mutilated paper Swartz created with fire. She wrapped this paper around an inner framework and then painted it. No longer paintings, these sculptural pieces evoked rocks or mountains. They were exhibited on platforms suspended by chains from the ceiling at Frank Marino's New York gallery in a show entitled "New Landscape Rituals, Arizona, 1981." Included in the installation, and related to the rock sculptures, was the *Fault Line Series.* These were also three-dimensional, but were attached to the wall as a frieze, in a line of separate but integrated pieces that seemed to be segments of a canyon wall.

Though Swartz continued to work with fire throughout 1981, she was beginning to lose interest in the technique. This process/ritual was no longer as compelling as it had once been, and her work reflected an increased fascination with design and symmetry. The *WingBeat Series* is a later flowering of a process/ritual that Swartz invented and had completely mastered. The butterfly theme, an abstraction in *The Cave of Machpelah,* became overt and stylized, precisely shaped forms. Sumptuous objects, rococo and regal, were combined with the fire process/ritual. When her friend and neighbor Colly Soleri (wife of architect Paolo Soleri) died, Swartz created the series *Colly's Dream* as a tribute to her. The form again

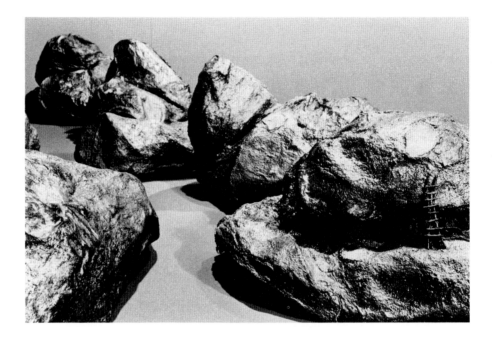

Rock Forms, 1980 installation shot, taken at the Frank Marino Gallery, New York, New York. (detail opposite)

is close to the figurative. *Aperture* and *Pathflower* are similarly in transition. Swartz knew from experience that when a personal dissatisfaction with her art set in, transformation would not be far behind.

Swartz did her last two major fire pieces in the summer of 1982, on commission from the Phelps Dodge Corporation. While she would in the future execute other fire paintings, Swartz's interest in the medium had waned by the end of the year. By this time, though she had not developed a new approach to her art, she had already taken a new path in her personal life.

"During 'Israel Revisited,' my art became an obsession. I ate and slept the project. When it finally got on the road, I collapsed physically and was completely out of balance."

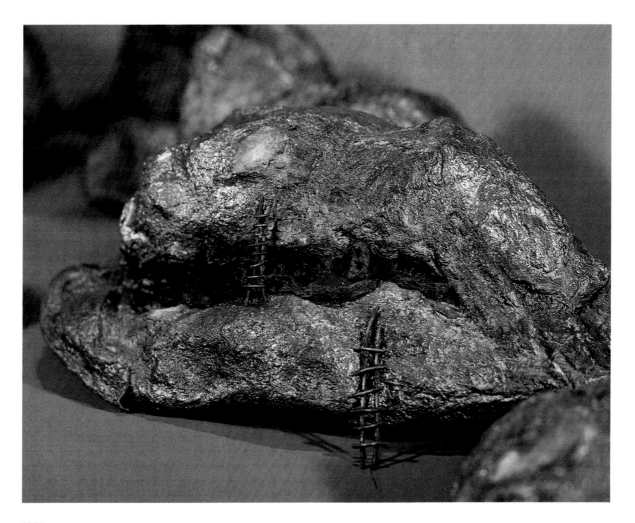

1980
Rock Forms
mixed media on handmade raw flax paper
5 x 7 inches to 21 x 14 inches,
mounted on 6 x 8-foot platform

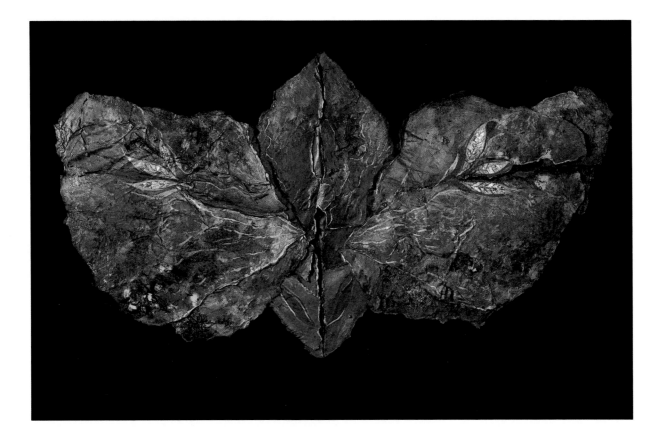

1982
Colly's Dream #1
fire, earth, sunlight, mixed media on layered paper
30 x 60 inches

Part of the reason for Swartz's collapse was the personal struggle she faced with her health. Operated on in October 1980 for a tumor, she was face-to-face once again with the possibility of serious illness or death. She made a crucial decision not to consign control over her body to anyone else, and refused to sign a blanket permission for radical surgery. The tumor was benign, but the recovery was slow and long. She also learned at this time that exposure to the fumes of her fire process had literally poisoned her system. The danger of the medium and her sense that she had taken the process as far as she wished forced her to seek ways to heal herself. Health, balance, wholeness, and calmness became central in Swartz's concerns. The conviction grew in her mind that, far from being weak or frail, she was a strong woman. She began to reevaluate herself and her life.

As the use of fire culminated, Swartz pulled through certain threads in her art that had developed over the previous two decades, particularly her use of rich color and vibrant surface. Texture for its own sake would be less important in her next phase but the suggestion of active, kines-thetic connections between artist and surface would be enhanced. Her work with fire and her study of the Kabbalah were tools through which she was able to explore and communicate another level of experience or knowledge.

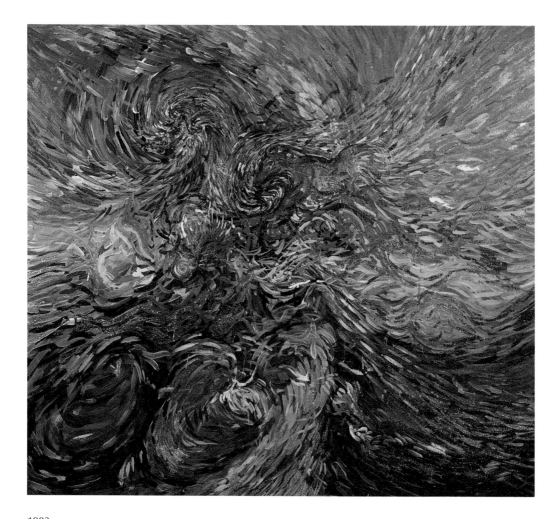

1983
Search
acrylic, gold leaf, microglitter on linen canvas
48 x 48 inches

A NEW DIRECTION

Full personhood insists on acknowledgement of the personhood of others. When we realize the inner self, we also reciprocally open our consciousness to the cosmos.

GEORGE T. L. LAND and
VAUNE AINSWORTH-LAND

Though she realized that her life and her art were again at a point of transformation, Swartz made a commitment to Karyn Elizabeth Allen, curator of the Nickle Arts Museum in Calgary, Alberta, to prepare for an exhibition to begin in Canada and tour also in the United States. She felt all the symptoms of unease, challenge, and resistance to the unknown, combined with her lack of well-being. She also had developed the wisdom to recognize her symptoms for what they were, and to prepare for an evolutionary development rather than a cataclysmic, forced changed such as she had undergone in her younger days.

"It seems as if every seven years the work develops and reaches a peak—then it's not enough. I'm always pushing through that black hole and pulling through what I need to a higher level. It's like jumping off a bridge and not knowing how to fly—you learn as you go down. Or it's like learning a new language. I don't plan for these transformations. They just occur. Often my work is ahead of my life.

"The hardest thing for me to deal with is the expression visually of what I feel emotionally, intellectually, and intuitively, to fuse them all together. I imagine that is true of every artist. Now, more than ever, I want the paintings to speak about healing and to serve as icons or talismans."

In her search for ways to heal herself, Swartz studied the ancient East-
ern belief in chakras, which posits an ethereal counterpart surrounding
the physical body. In the chakra system, spiritual energy, known as prana
or kundalini, enters the human body through a chakram, or vortex, which
corresponds roughly with an endocrine gland. A chakram is associated
with a color. In brief, the red chakram corresponds to the reproductive
organs as well as the base of the spine; similarly, the orange chakram with
the pancreas; yellow chakram with the adrenals; pure yellow with the
solar plexus, the body's central region; green chakram with the heart and
thymus; blue with the thyroid; variations of lavender to purple with the
pineal—depending upon the openness of the person to prana, the color
will lighten. Although there is a variation among interpretations of the
chakra system, they agree in their ladderlike conjoining of color, chakram,
and body part.

Swartz found a correspondence between chakras and the Tree of Life,
especially the Tree of Life as conforming with the body of Adam-Kadmon,
the primordial image of man. She had a sense of treading on familiar
ground in this new study. Looking for a mode of self-healing, she was
attracted by the idea that for a person to be considered whole, healed,
well—words that spring from a similar root—the flow of prana to the
physical body through the chakras must be unimpeded by ego, negativity,
or any form of baseness. Rhythmic breathing, meditation, and sound diet
enhance the flow of prana. She began to practice a regimen that was in
keeping with this system.

As Swartz undertook her exploration of this Eastern belief, she also
sought to integrate it with her art. The color system of the chakras and the
need for balance in herself became components of another holistic synthe-
sis. How she would approach the art itself she did not yet know.

Swartz decided to begin working with the chakra colors, one by one.
She started with the red chakram because it was the first, or lowest, in the

diagram of the body. To connect the work more closely with healing, she chose to paint at a site considered to be both sacred and healing. She drove alone four hours north of Phoenix—part of the time on a paved road and the last nine miles, on a dirt road—to Moon Rock, one day before the night of the full moon in September 1982. The site is on property owned by Synaine C. Richard, a numerologist and friend who stays there much of the time, but who was away when Swartz made her visit. Swartz had been to Moon Rock several times previously, and made herself comfortable in her friend's home. Swartz recalls an experience which began the next morning, an experience that altered her creative perception.

"I worked with red foods; I lit a red candle and built an Indian medicine wheel in a northeast, southwest direction using thirty-two rocks. Within the circle of rocks, I meditated and then painted a fire piece. I didn't know what kind of art I would do; I just wanted to connect with the chakras.

"Then it started to rain. Although I had planned to spend a second night because that was the night of the full moon, I decided I'd better leave—the road was muddy and if it rained very hard I'd never get out. As it turned out, I got stuck anyway; I left my badly tilted car and started walking. By this time, it was beginning to get dark, and I was cold and hungry and had no flashlight (none of the things you're supposed to have for survival on the desert!). I crossed a barbed wire fence and went through a field toward the lights of a farmhouse in the distance. Suddenly, I felt that if I went any further, I would fall into a void. I got down on my hands and knees and moved slowly forward. I hadn't gone very far when I felt that the ground dropped away. Had I continued, I would have fallen into a deep, water-filled wash. I remembered that I had passed a small shack, and returned to it, still crawling, guided by patches of moonlight breaking through the clouds.

"Once there, I actually broke open the door and it fell completely off

its hinges—I found I had a lot more strength than I'd realized. Time became relative, expanded, once I was inside. It felt like an hour, but it was really only a few moments. I tried meditating. Then I heard rustling noises and became quite alarmed. I looked out the open doorway of the building and saw two horses, a white one and a black one. They walked right up to the doorway and stood quietly, looking at me. My fear turned to a feeling of great protection and I was able to fall asleep. The next morning, I was able to locate someone to help me with my car, and I drove home safely."

After this experience, Swartz attended a workshop at the Esalen Institute in Big Sur, California, given by Michael Harner, the author of *The Way of the Shaman.* At one point in a shamanic healing session, Swartz described her adventure with the horses, and Harner told her she had had a typical "vision quest," similar to that of young North American Indians who went out into the wilderness alone in search of a power animal. In retrospect, she felt he had given the proper name to her experience. Those horses did seem to have appeared in order to protect her. She had been on a vision quest without realizing it.

As had happened before, Swartz was changed by a visionary experience. She believed that what happened to her at Moon Rock was a life/death experience, in that she could have fallen into a deep ravine in the dark. Her most recent work reflects her new concern for organic life. For the first time in twenty years, she started drawing animal forms as components of her paintings. Her return to figurative work after many years as an abstract artist is only one aspect of her transformation. She has also begun painting in acrylic on canvas, and doing monoprints of archetypal images which she treats as power symbols within layers of color and abstraction.

The use of animals within Swartz's work was dramatically reinforced when she and her husband spent a month in France during the summer of 1983. On a trip to the caves of Font-de-Gaume, Swartz saw bison and

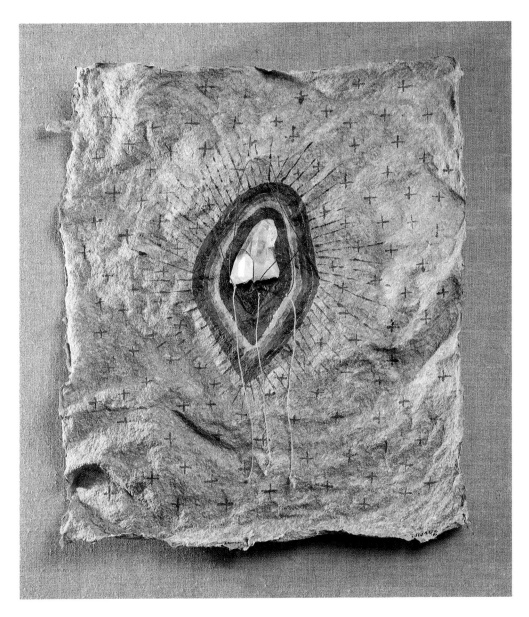

1982
Healing Icon
acrylic and crystal on paper
16 x 12 inches

109

horses painted on the walls some 14,000 years ago. They seemed connected with her vision quest. "I could sense the special purpose for which these animals were painted. The caves were used for religious ceremonies, perhaps for healing or protection." She was affected by this cave art and it strengthened her commitment to working with animal symbols for a healing purpose of her own.

Animals are not the only symbolic figures to appear in Swartz's new paintings, however. Combined with chakra colors, crystals are included in some of the work she has done since her vision quest. *Healing Icon*, a painting on handmade raw flax paper, houses a crystal within ribbons of color, each color representing a chakram. Viewed as a talisman with curative powers, the work bridges the change from the late fire pieces to the new canvases. The crystal becomes part of a fetish, and also part of a work of art, yet it remains clearly of the earth. Crystals have been credited with healing power by many cultures in different eras. Swartz wanted to capture the crystal's tangible beauty and the intangible associations that it has with the esoteric, so she sewed it to the work.

The tangible and intangible appear once again in Swartz's next major painting. In recounting her memories of creating the large canvas *A Moving Point of Balance #1*, which is seven feet square, Swartz says she became aware within a few hours of a bold form emerging; soon, the shape evolved from a treetrunk into the headless female torso which now dominates the work. Swartz worked on the painting for nearly six months, and it is supercharged with animals, spirals, the lotus, a wheel, and dynamic swirls of brushstrokes. As an object of contemplation, an active mandala enclosing repeated circles, the painting is intended to energize the viewer.

This work is one of seven major paintings that comprise the series *A Moving Point of Balance*, painted on a ground color associated with a chakram. The first piece is painted on red-toned canvas which refers to

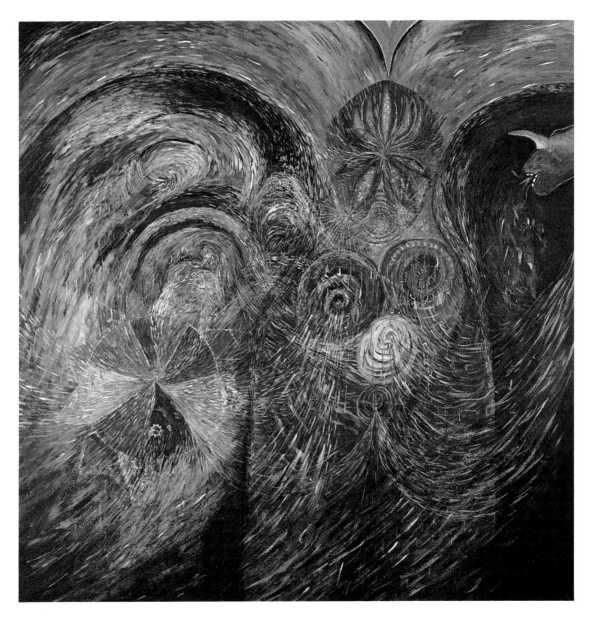

1983
A Moving Point of Balance #1
acrylic, metal leaf, microglitter on canvas
84 x 84 inches

the chakram that energizes the reproductive organs as well as the base of the spine. The kinship with animal life that prompted the imagery in the work is a result of Swartz's experience at Moon Rock. She related the sense of protection given her by the guardian horses with the physical energy that is nourished through the red chakram. In this first piece of the new series, Swartz consciously tried to open herself to incoming spiritual energy by working with the red color of the chakram and with organic symbols. Her intention was to invest the work with the potential for healing. The painting was exhibited in June 1983 with several related works at Elaine Horwitch's Santa Fe gallery.

While in Santa Fe for the opening of the show, Swartz learned about a tour of sacred Indian sites to be led by Hopi authority John Kimmey. Over twenty people were to be in the group, which would be accompanied by Hopi artist and medicine man Preston Monongye. Swartz was able to secure the last two spaces; in another well-timed coincidence, Linda Bryant, a friend who owned a jeep, expressed interest in joining her—serendipitously, since a jeep was a necessity.

The group started their ten-day trek at "the great womb" of the Grand Canyon and then visited Prophecy Rock in Hopi land; the meaning of the prophecy was translated for them. While at Chaco Canyon in New Mexico for the summer solstice, during his prayer ritual, Monongye blessed Swartz's project, *A Moving Point of Balance,* and said it was of "one heart." The caravan completed the tour at Taos Pueblo on the northern Rio Grande. The journey provided what Swartz calls an authentic connection between herself and sacred southwestern spaces. This freed her to draw upon the energy of these places in painting her healing series.

As her work evolves, Swartz has been connecting with the natural world in various stages of growth. *A Moving Point of Balance* expresses her awareness of mind/body unity. Fritjov Capra, in *The Turning Point,* writes of this as the existential level of consciousness "of the total or-

Linda Bryant

Swartz took part in a "spiritual community" during the 1983 Four Winds Circle pilgrimage to Indian holy sites.

ganism, characterized by a sense of identity which involves an awareness of the entire mind/body system as an integrated, self-organizing whole."

The recent changes Swartz has experienced in consciousness have led her to the most radical technical changes in her art since she began working with fire. She has taken a major risk in moving from paper to canvas, and a further one by expressing herself as a figurative artist. For over twenty years, her work has been inspired by the need to express ineffable thoughts. Since 1971, abstraction has been the vehicle through which she has given voice to her inner life. Now, she feels impelled to take a direction she abandoned years before. Once again, she is drawing recognizable forms with her brush.

In weaving together her heightened awareness with the desire to express herself more forcefully, Swartz requires a larger loom. Canvas presents a new challenge, but she brings to it threads of her art already well established on paper. Color is the most obvious aspect of her style; the luxurious addition of metal leaf is another. For increased sparkle, she often adds microglitter mixed with pigment. The artist has brought forward the energy first exhibited when she danced around the paper, painting her *Staccato Series.* The dance is different now, more confrontational, but still unpremeditated. Texture, which identified her fire pieces, has given way to the surface embellishment of brushwork. She applies several layers of brushstrokes, each of which have separate functions. Large masses, figures, and color fields form a solid base layer. In the mid-layer, Swartz defines the design, which exists, like her earlier work, on the picture plane, without a suggestion of perspective. The allusion to space is one of simultaneity of events receding beneath the surface in the manner of thoughts; it is not a linear, but a holistic concept. Near the surface, brushstrokes are rapid dashes, seminal in their sense of bursting from a center, and they follow spiral pathways that enliven the painting while also serving as a screen of energy through which the figurative elements

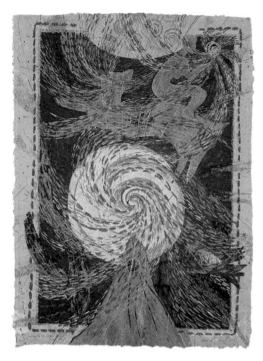

1983
Journey to the Upper World
serigraph with microglitter on handmade paper
30 x 22 inches

are viewed. Glitter is the final embellishment. A semaphore of tinted glitterstrokes follows its own related pattern of spirals and adds the touch of elegance that has long identified Swartz's style.

In making this transition, Swartz has come through another creative black hole and is at the very beginning of the next stage of aesthetic growth. Already, she has translated the new layering of her *Balance* series into silkscreen prints which require over thirty runs of color and six of glitter.

Before painting this series, Swartz connected shamanism with the study of the chakras. She recalls the various threads she brought together into the synthesis that undergirds the new paintings. "In February, after my workshop with Harner, I read Julian Jaynes's book, *The Origins of Consciousness and the Breakdown of the Bicameral Mind.* From his references to right- and left-brain consciousness, I realized that I am attempting, in my new work, to connect with the early right brain, part of our collective unconsciousness, when magic ruled the mind. The shamanic journey that I am on is a way of starting again, on yet a different level of connectedness." Swartz wants to face the canvas in an innocent frame of mind, without preconceived plans. She compares this stance to a "continuous prayer," and says, "I don't want to hold anything back as I work. Throughout the years, it seems as if I have kept stripping away layers of myself in my effort to gain more strength and emotion in my work."

Swartz's art has become for her, and perhaps for her viewers, too, a source of healing power. In the half-year she worked on *A Moving Point of Balance #1,* Swartz also worked at balancing her personal relationships. "Sometimes to be open, to be honest, to be loving, to be mature, to be intelligent is not enough if all that you are doing is just building furniture without really living in your house. It has taken me all these years to realize that I want my day-to-day life to have a moving point of balance, moving because it can never really be firmly fixed. It always changes."

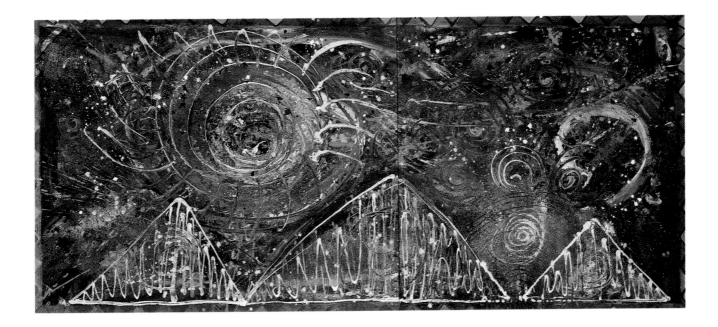

1983
Aurora Borealis #2
mixed media and microglitter on linen canvas
48 x 108 inches

*Full personhood insists on acknowledge-
ment of the personhood of others. When
we realize the inner self, we also recipro-
cally open our consciousness to the cosmos.*

GEORGE T. L. LAND and
VAUNE AINSWORTH-LAND

In any marriage, both partners often change or evolve. Melvin Swartz revealed that he, too, was at a point of transformation, anxious to leave the law and develop his talents as a writer and in other creative areas. Together, the Swartzes decided that he would sell his practice and she would undertake partial financial responsibility for the family. Soon after Jonathan's bar mitzvah in the spring of 1983, Melvin Swartz left the law; Swartz postponed her Canadian opening for a year; it was just at that time of decision and change that the couple left for a month in France.

Not long after their return, Swartz learned that her mother's health was again fragile. She spent time with her parents and sister, aiding in practical ways and sharing memories. These hours stirred her emotions and led to fresh observations. "For the past ten years, there has been a slow role reversal as my father has gradually taken over all the household tasks due to my mother's affliction with Parkinson's disease. Thus, in their fifty-eight years of marriage, they have a sense of devotion and shared purpose that I admire. My mother's courage in dealing with her illness has been admirable. She will not give up. Her interest in her plants, letters from her friends, and the young people around her is remarkable."

Interjected as it was between a time of change in her marriage and a period of intense painting, the visits with her family had a positive effect on Swartz. She reacted to the stress of her mother's illness very differently than from a decade before. The admiration she felt for her parents' strength alleviated her previous ambiguity about her role in the family. She knew she had inherited their steadfastness and could depend upon it. The purposefulness that her family believes in is a value she shares, and she recognizes that her relationship with her family has come of age and entered a new and more comfortable phase.

"I have done my work throughout the years in tandem with my other roles. Part of what I want to share with other women and men is that there is always another door to walk through. We as humans have incalculable

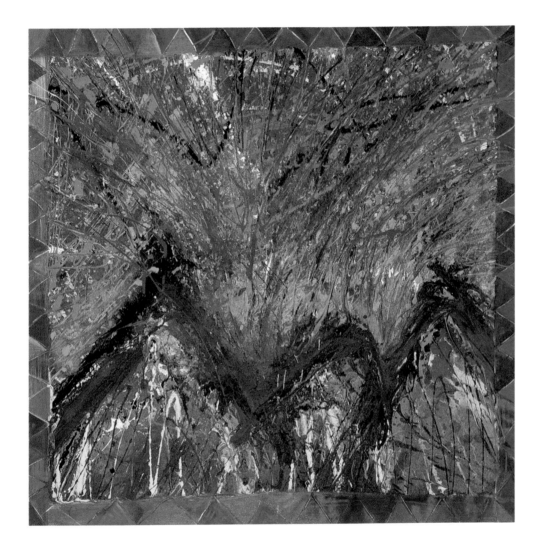

1983
Aurora Borealis #7
acrylic and microglitter on linen canvas
60 x 60 inches

potential to grow and mature throughout our lives. Having the courage to move on, to face the unknown, sometimes seems more foolhardy than mature. But, if it feels right, you're probably on the path to real growth."

To find one's own path, one's ideal, is a victory, but it does not remove hazard. Living an ideal is the greatest challenge. Many metaphysical scholars conclude that ultimate enlightenment comes only to those who forfeit their own ego, who surrender it to the source of All That Is. It is paradoxical for an artist who seeks wisdom through metaphysics to open herself or himself to this final necessity. What could be a more dangerous door to enter than the one that leads to egolessness? The artist, more than most, is the very model of a person who needs a strong sense of identity, a healthy ego from which to create confidently. Is the initiate capable of creating? Or, is the master completely absorbed in contemplation and worship?

The most that can be hoped for by anyone involved in this process is to achieve balance on the thin edge between maintaining one's own will, or ego, and losing it to gain the radiance of Kether on the Tree of Life, or to open the last chakram to the Light. Increasingly, seekers in the present age are sharing their discoveries of esoteric knowledge with others. Communicating is a form of educating, or literally "leading out." Swartz is a communicator, via her art, of her own experiences in life and the spiritual ideal she has continually rediscovered along her journey to wisdom. The connecting interaction Swartz has achieved in her intellectual, artistic, and personal lives forms the foundation of a fulfilling growth process, the future stages of which are yet to be revealed.

In Swartz's art, content is expressed but not stated or directly illustrated. The transmission of content through visual art without accompanying documentation is a challenge which she has readily, even eagerly, accepted. Although Swartz is no longer a teacher, her art is an avenue through which she shares or teaches her experience. This teaching/sharing

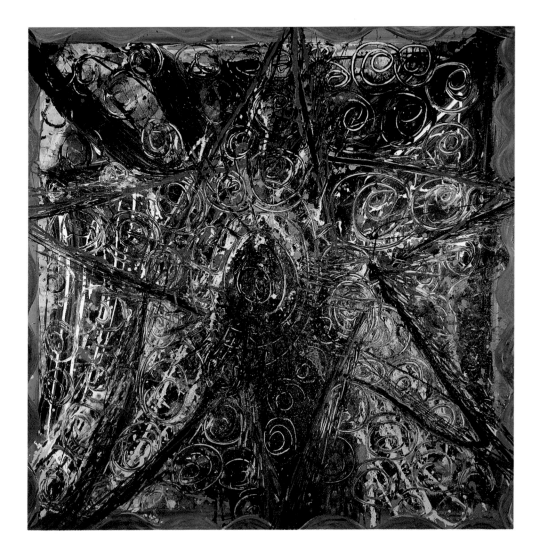

1983
Aurora Borealis #4
acrylic and microglitter on canvas
60 x 60 inches

impulse motivates the work she has created since "Inquiry Into Fire." There is an increasing effort on her part to connect less equivocally with viewers, to convey her philosophy more clearly. She has messages to impart. The need to balance beauty with content continues to be a central issue in her development.

Adin Steinhaltz, in *The Thirteen Petalled Rose,* writes: "Every *mitzvah* that a man does is not only an act of transformation in the material world; it is also a spiritual act, sacred in itself." The art of Beth Ames Swartz is a *mitzvah,* her gift of a spiraling and transforming art on the frontier of her consciousness.

CHRONOLOGY

1936 Beth Ellen Ames, born February 5th, New York City, third child of Dorothy Andres Ames and Maurice U. Ames. (brother, Bruce, b. 1929, sister, Sylvia, b. 1932). Both parents' families Jewish immigrants; concerned with heritage but do not actively practice religion.

Lives at 590 Fort Washington Avenue, New York City throughout childhood. Enjoys the nearby George Washington Bridge, the water, and Fort Tryon Park.

Mother encourages creative activity through drawing, painting, dancing, singing, and piano lessons.

Spends summers with family at a camp in the Adirondacks.

An aunt, Rachel Andres, teaches her music and watercolor technique.

An aunt and uncle (Ricky and Aaron Andres), collectors of modern art, recommend books to be read.

1948 Begins weekly lessons at Art Students League, and visiting the Museum of Modern Art.

1949 Graduates from PS 187, takes and passes entrance exam to attend High School of Music and Art. Studies the use of many different media during daily art classes.

Reads extensively, especially novels. Develops an active imagination early in life and a sensitivity to a private existence through which a process of "working out" becomes trusted; writes poetry.

1953 Graduates from High School of Music and Art. Applies to and is admitted as a student in the College of Home Economics (now called College of Human Ecology), at Cornell University.

Continues to use poetry and art as a means of expression, particularly interested in philosophy and psychology.

Meets and works with Frances Wilson Schwartz, a professor in Child Development Department; decides art in relation to education, or as personal expression, will be her life's work.

1954 Attends Cornell for two years, under the auspices of Child Development Department; assists Frances Wilson Schwartz with family art classes.

Reads *The Biology of the Spirit* by Edmund Sinnot, on the recommendation of Frances Wilson Schwartz. Thesis of the book, that all growth is purposeful and that spiritual growth is vital, becomes an important part of her personal philosophy.

1956 Arts and Crafts Director of a summer camp in the Catskills; inspired by response of students and parents to creative teaching techniques.

Graduates from Cornell in three and one half years; remains for another semester to assist Frances Wilson Schwartz and to audit a modern poetry class with an emphasis on the works of W. H. Auden and T. S. Eliot.

Spends three months in Europe with Edith Wachenheim (another art student), visiting museums in England, France, Italy, Denmark, and Switzerland. Particularly enjoys classical and impressionist art; recognizes the great stream of history seen through art; and is impressed with the grandeur of nature, especially the Swiss Alps.

Begins teaching at junior high school, PS 80 in the Bronx. Teaches English, poetry, and art.

1958 Begins night classes (mostly studio) in art education at New York University. Working in oil in semi-abstract manner on canvas.

Takes trip to Mexico during summer months.

Frances Wilson Schwartz dies of cancer at the age of thirty-nine, leaving Beth her papers and library.

Does a portrait from memory of Frances Wilson Schwartz. (In private collection of Victor D'Amico, former Director of Education, Museum of Modern Art, New York City.)

Begins experimenting with watercolor on paper.

1959 Switches to watercolor technique exclusively.

Receives M.A. degree in art education from New York University.

December 27th, marries Melvin Jay Swartz, honeymoons in California, moves to Phoenix, Arizona. Considers the Arizona environment harsh and alien.

1960 Paints a group of cityscapes recalling the view from the third floor window of her New York home.

Interest in poetry continues, paints landscapes titled with poetry from e. e. cummings and T. S. Eliot.

Returns to New York City during summer months for short visits.

Begins teaching at Yavapai School in the Scottsdale School System.

Exhibits:*

Arizona State Fair (through 1965)

1961 Exhibits:

Third Arizona Annual at Phoenix Art Museum (exhibited an oil painting, *Rising Sun,* painted prior to her arrival in Arizona.)

1962 Begins teaching at Kaibab School in the Scottsdale School system.

Exhibits:

Gatti Studio, Scottsdale, Arizona (two person)

1963 Joins with other artists in forming an Artist's Cooperative. (Charter members included Rip Woods, Muriel Zimmerman-Magenta, Barbara Bennett, Joseph Gatti, and Eugene Grigsby; later joined by Dagne Yares and Darlene Goto.)

Exhibits:

Artist's Cooperative, 20th St. and Camelback, Phoenix, Arizona

March 3, Douglas Hale, "Teachers Open Gallery," *The Arizona Republic,* p. C 18.

March 10, Carol Osman Brown, "Artists 'Set up' Shop," *The Phoenix Gazette,* p. 18.

March 31, "Newsroom of the Republic Quite 'Arty,' " *The Arizona Republic,* p. C 18.

April 7, Joan Bucklew, "Ten Artists in New Valley Group Display their Work," *The Arizona Republic,* p. 18.

1964 Stops full-time teaching to devote more time to painting; recognizes tie between her developing art and own personal growth.

Begins teaching in extension division of art department, Arizona State University. Develops arts and crafts program for elementary teachers.

December 12, Carol Osman Brown, "Artist Captures Creativity," *Phoenix Gazette,* p. 18.

1965 Part-time consultant to VISTA and Head Start Programs.

Lectures on creativity throughout the Southwest.

Listed in *Who's Who in American Women,* n.p.†

Exhibits:

Alhambra Invitational, Phoenix, Arizona

Frazier residence, Tempe, Arizona (solo, five-year retrospective)

1966 Travels to San Miguel de Allende, Mexico; spends approximately six weeks in an art colony actively pursuing artistic interests; does first lithograph.

Exhibits:

Alhambra Invitational, Phoenix, Arizona

*arranged alphabetically

†no page and/or publisher information

Casa Grande Art Festival, Casa Grande, Arizona
(1st prize/watercolor)
Cave Creek Gallery, Cave Creek, Arizona
Galerias Glantz, Mexico City, Mexico (solo)
Los Robles Gallery, Palo Alto, California

1967 April 27th, daughter Julianne is born. Birth of child
gives a sense of being "connected" to Arizona.
Experiments with non-objective color, pointillism,
pouring, dripping of paint, uses acrylics in a
manner similar to watercolor, and in a larger
format.
Listed in *Who's Who in the West* (Marquis Pub-
lishing Co.)
Exhibits:
Martin Gallery, Scottsdale, Arizona, (solo)
Phoenix Little Theatre Gallery, Phoenix, Arizona
Scottsdale Artist's League (Honorable Mention)
March 12, J.B., "Little Theatre Exhibits Swartz,"
A Magazine for the Fine Arts, p. 10.
November 24, Barbara Perlman, "Gallery Hop-
ping," *The Arizonian,* pp. 21–22.

1968 Begins using serrated knife and fingernails to mark
paper.
Listed in *Dictionary of International Biographies*
(International Biographic Center Pub.)
Exhibits:
Alhambra Invitational, Phoenix, Arizona
Arizona Artist's Guild, Phoenix, Arizona (Merit
of Distinction)
First Watercolor Biennial, Phoenix Art Museum,
Phoenix, Arizona
Martin Gallery, Scottsdale, Arizona (solo)
Northwest Art Festival (3rd place/watercolor)

1969 Becomes interested in civil-rights movement, paints
Confrontation in Black and White.
Exhibits:
Canoga Mission Gallery, Canoga Park, California
Eight State Regional Watercolor Exhibit (traveling
exhibition)

Jewish Community Center, Phoenix, Arizona,
Third Invitational, Phoenix, Arizona
Martin Gallery, Scottsdale, Arizona (solo)
December, work reviewed by Marlan Miller, *Phoe-
nix Gazette.*

1970 Son, Jonathan, born April 1st.
Sees work of John Marin at Los Angeles County Art
Museum that has a "cut-out" collaged to paper.
Begins experimenting with watercolor collage.
Writes "You Can Help Your Child Create," a pam-
phlet distributed by the Phoenix Parks and Rec-
reation Department.
Trip down the Colorado River on a raft stimulates a
group of paintings depicting woman in the land-
scape, translations of Arizona's topography.
Art critic in Mexico City describes Swartz as "mas-
ter of the controlled accident."
Exhibits:
Galeria Janna, Mexico City, Mexico (solo)
Memorial Union Gallery, Arizona State Univer-
sity (solo), (*She is Joined to the Soul of Stone*
purchased for the Arizona State University Art
Collections, Tempe.)
Rosenzweig Center Gallery, Scottsdale, Arizona
(solo)
Tucson Fine Arts Festival, Tucson, Arizona (1st
prize/watercolor)
March, Toby Joysmith, "Beth Ames Swartz," *Mex-
ico City News,* n.p.
November, "Work of Beth Ames Swartz," *Phoenix
Gazette,* n.p.

1971 Instrumental in forming "The Circle," a group of
women artists working and showing together
until 1975.
Spends summer in San Miguel, Mexico, working
with the flow of color in water on canvas and
paper.
Decides more attention to color is needed, begins
two-year study with Dorothy Fratt.

Using meditation to quiet the mind, starts *Meditation Series.*
Exhibits:
 Martin Gallery, Scottsdale, Arizona (solo)
 Tucson Fine Arts Festival, Tucson, Arizona
 Western States Regional Watercolor Exhibition (Show tours under the auspices of the Rocky Mountain Arts Foundation, 1972, 1973)

1972 Begins the study of Zen.
Exhibits:
 Casa Grande Arts Festival, Casa Grande, Arizona (1st prize/watercolor)
 Grady Gammage Auditorium Gallery, Arizona State University (solo)
 Memorial Union Gallery, Arizona State University (solo)

1973 Begins *Projected Power Series*
Exhibits:
 Touring Show, Auspices of Arizona Commission on the Arts and Humanities
 University of Arizona, Tucson, Arizona

1974 Meets George T. Lock Land, whose book *Grow or Die; The Unifying Principle of Transformation,* influences thoughts on life and art.
Begins series on elements; *Umi, Air, Flight, Prana,* and *Earthflow.*
Exhibits:
 Joslyn Art Museum, Omaha, Nebraska
 Ninth Annual Southwest Invitational, Yuma, Arizona
 Western Colorado Center for the Arts, Grand Junction, Colorado

1975 Exhibits:
 Arizona Women '75, Tucson, Arizona
 Glendale Community College, Glendale, Arizona, "Dimensions '75" (Honorable Mention for *Umi #3*)
 Pavilion Gallery, Scottsdale, Arizona (solo)

Museum of Art, Austin, Texas (touring exhibition, watercolor award)
 Texas Fine Arts Association, 64th Annual Exhibition, Laguna Gloria Museum, Austin, Texas
Marlan J. Miller, "Introduction," *Glendale Exhibition of the Circle Catalogue.*
May, Barbara Cortright, "The Look of Nature, the Flow of Paint," *Artweek,* p. 4.

1976 January, hears a lecture by, and meets Elisabeth Kübler-Ross.
Comes to the end of lyrical abstraction period.
Facing the reality of death due to mother's illness, creates *I Love Mommy* Series.
Attends lecture about feminist imagery by Lucy Lippard.
October, travels to Israel with husband, has an emotional identification with heritage.
Begins smoke images, working with fire. Color reduced by conscious choice while developing new process and technique. Many experiments, including piercing the paper and using actual elements.
Begins work for a show at the Scottsdale Center for the Arts, scheduled for 1978.
Listed in *Who's Who in American Art* (Jacques Cattell Press) and in *International Who's Who in Art and Antique* (International Biographies Pub.).
Exhibits:
 Albuquerque Museum of Art, Albuquerque, New Mexico ("Four State Watercolor Biennial")
 Arena National Competition, New York, New York
 Attitudes Gallery, Denver, Colorado (solo)
 Bob Tomlinson Gallery, Albuquerque, New Mexico
 Fine Arts Museum, Santa Fe, New Mexico ("Looking at the Ancient Land")
 Sally Caulfield Gallery, Binghamton, New York

April, Barbara Henderson, "Beth Ames Swartz," *A Magazine of Fine Arts,* pp. 34–41.

April 7, Eniko Szeremy, "Of Introspection and Airbrushes," *Rocky Mountain Journal,* Vol. XXVI, No. 29, p. 43.

April 11, J. Mills, "Earthflows at Attitudes," *Sunday Denver Post,* n.p.

September 17, William Peterson, "Show's Paintings by Beth Swartz address Special Moments of Life," *New Mexican Independent,* n.p.

1977 Use of fire becomes bolder, researches other artists' use of fire.

Begins ritual approach to painting; ordering, disordering, reordering process.

Creates *Cabala* and *Torah Scroll* series.

Listed in *World Who's Who of Women.*

Exhibits:

 Bob Tomlinson Gallery, Albuquerque, New Mexico (solo)

 Colorado Springs Fine Arts Center, Colorado Springs, Colorado (Retrospective of prominent southwestern artists: "Ten Take Ten")

 Janus Gallery, Los Angeles, California

 Phoenix Art Museum, Phoenix, Arizona ("Four Corner Biennial")

 Southwestern Invitational, Yuma, Arizona

William Peterson, "Review of 'Ten Take Ten' Exhibition," *Artspace,* n.p.

Colorado Springs Fine Arts Center, "Ten Take Ten," *Exhibition Catalogue,* pp. 27–29.

June 15, Barbara Perlman, "Artist Charts New Beginnings in Work," *Scottsdale Daily Progress,* p. 42.

July 17, Irene Clurman, "10 Works of 10 Artists Reveal Vital Insights," *Rocky Mountain News,* p. 14.

Fall, William Peterson, "Beth Ames Swartz at Bob Tomlinson Gallery," *Artspace,* n.p.

Fall, "Beth Ames Swartz, 'Inquiry Into Fire,' " *Arizona Artist Magazine,* pp. 3–4.

1978 March, travels to Houston to see the Cézanne exhibition, visits the Rothko Chapel at Rice University, Houston, Texas.

Receives a letter from Barbara Rose, encouraging trip to New York City (went in October).

July, invited to participate in the First Western States Biennial.

Begins *Sedona Series.*

Exhibits:

 A.D.I. Gallery, San Francisco, California ("Works on Paper")

 Artel Gallery, Albuquerque, New Mexico (solo)

 Gargoyle Gallery, Aspen, Colorado

 Jasper Gallery, Denver, Colorado (solo)

 Memorial Union Gallery, Arizona State University, Tempe, Arizona ("Expanded Image on Paper," with Susan Weil and Adrienne Wortzel)

 Scottsdale Center for the Arts, Scottsdale, Arizona (solo: "Inquiry Into Fire")

 Springfield Art Museum, Springfield, Missouri (solo)

Inquiry Into Fire Exhibition Catalogue, Scottsdale Center for the Arts. Introduction by Melinda Wortz.

February 25, Barbara Cortright, "Fire as Process and Image," *Artweek,* p. 16.

March 31, Karen McKinnon, "Beth Ames Swartz Brings Rebirth To Her Work by Daring Destruction," *The New Mexico Independent,* pp. 1, 8.

April, Melinda Wortz, "The Fire and the Rose," *Art-news Magazine,* p. 112.

June 22, Katharine Chafee, "The Fiery Art of Beth Ames Swartz," *Straight Creek Journal,* pp. 1, 11.

Winter, Barbara Cortright, "Beth Ames Swartz: The Signatory Aspects of Prometheus," *Artspace Magazine,* pp. 10–16.

1979 Spring, studies with Sandy Kinnee, Colorado Springs, Colorado; learns handmade paper technique, makes four silkscreens.

August, artist-in-residence at the Volcano Art Center, Hawaii.

Begins *Black/Green Sand Beach Series*

Fall, does *Sedona and Hawaii* silkscreen series with Joy Baker, Southwest Graphics.

Exhibits:

 Elaine Horwitch Galleries, Scottsdale, Arizona (solo)

 Ellen Terry Lemer Ltd., New York, New York (solo: "Earth/Sunlight/Fire")

 First Western States Biennial (touring invitational exhibit organized and administered by the Western States Art Foundation; visited Denver Art Museum, Denver, Colorado; National Collection of Fine Art [now, National Museum of American Art], Smithsonian Institution, Washington, D.C.; San Francisco Museum of Modern Art, San Francisco, California; and others; tour continued until 1981)

 Frank Marino Gallery, New York City (solo)

 Phoenix Art Museum, Phoenix, Arizona (Biennial, invitational)

February/March, "Beth Ames Swartz at Frank Marino Gallery," *Artworld,* n.p.

March 25, Irene Clurman, "On Fiber Work, Flapping Wings and Flamed and Frozen Paper," *Rocky Mountain News* "Now," p. 13.

April, Bill Marvel, "A Move to Edge U.S. Art Focus Towards the Pacific," *Smithsonian Magazine,* p. 115.

May 20, Irene Clurman, "Molded, Folded, Torn, Painted Works of Art," *Rocky Mountain News* "Now," p. 17.

May, Robbie Ehrlich, "Beth Ames Swartz—Frank Marino Gallery," *Arts Magazine,* p. 40.

June/July, "Artist's Theme: Rebirth by Destruction," *The Volcano Gazette,* p. 4.

July 26, John Perreault, "Western Omelet," *Soho Weekly News,* p. 56.

August 20, April Kingsley, "West Meets East," *Newsweek,* p. 79.

Fall, Mary Carroll Nelson, "Beth Ames Swartz," *Artists of the Rockies & the Golden West,* pp. 60–63.

Fall, Lori Simmons Zelenko, "Vernissage," *LiOfficiel/USA Holiday,* pp. 28–30.

1980 April, travels in Israel, makes pilgrimage to ten historical sites, starts *Israel Revisited Series.*

August, artist-in-residence, Sun Valley Art and Humanities Center, Sun Valley, Idaho, for conference titled, "The Awesome Space: The Inner and Outer Landscape."

Exhibits:

 Elaine Horwitch Galleries, Scottsdale, Arizona (solo)

 Frank Marino Gallery, New York, New York

 Rockland Center for the Arts, Reno, Nevada (Invitational, curated by A. Soteriou)

 Sierra Nevada Museum of Art, Reno, Nevada (Invitational touring under the auspices of the Western Association of Art Museums: "Artists in the American Desert")

February 1, Carol Kotrozo, "Mixing her Media Does the Trick for Beth Ames Swartz," *Scottsdale Daily Progress—Weekend,* p. 35.

February, Carol Kotrozo, "Beth Ames Swartz," *Arts Magazine,* p. 11.

March 19, Kyle Lawson, "Artist Fires Creative Elements," *The Phoenix Gazette NE,* pp. 10–11.

August 21, "Disorder Transforms her Multimedia Art," *Ketchum Roundup,* Sun Valley, Idaho, pp. 4–5.

October 5, Ed Montini, "Layers, Pieces of Art and History Merge into a Lifetime's Work," *The Arizona Republic,* p. G 1.

December, Barbara Perlman, "Varied, Energetic and Exciting," *Artnews,* pp. 146–49.

Winter, Barbara Perlman, "Rites of Fire and Transformation," *Arizona Arts and Lifestyle,* pp. 34–41.

Winter, Donald Locke, "Beth Ames Swartz," *Artspace Magazine,* pp. 44–45.

Lorinda Lo Presti and Ruth Vichules, "Trial by Fire," *Woman Image Now,* Arizona State University, Tempe, Arizona.

1981 Spring, John Perreault visits studio.

Begins *Illuminated Manuscript, Buried Scroll* series.

February and April, travels to Alexandra Soteriou's Atelier du Livre, New Jersey; works with raw flax, handmade paper.

June, raft trip down the Colorado River; reconnects to topography; begins large, free-form pieces for "New Landscape Rituals."

Harry Rand and Ruth Ann Appelhof visit Arizona to work on articles for "Israel Revisited" catalogue.

Completes "Tree of Life," ten-part, eighteen-foot-high work (privately purchased and donated to Yuma Art Museum, Yuma, Arizona)

September, finishes "Israel Revisited"; preview showing for sponsors at Elaine Horwitch Galleries, Scottsdale, Arizona.

Completes "Ten Sites Series Silk Screen Suite"; ten images in an edition of thirty, all handfinished; curated by S. Morgenstein; tours Jewish community centers and Judaica museums nationally.

Lectures and works with docents at each opening of "Israel Revisited" for two and one-half years.

Exhibits:

Arcosanti Festival, Arcosanti, Arizona

Arkansas Art Center, Little Rock, Arkansas ("Artists in the American Desert")

Frank Marino Gallery, New York, New York (solo: "New Landscape Rituals")

Fresno Art Center, Fresno, California ("Artists in the American Desert")

Jewish Community Center, Rockville, Maryland (solo)

Jewish Museum, New York, New York (solo: "Israel Revisited")

Kaiser Center, Oakland, California ("Artists in the American Desert")

Laguna Gloria Museum," Austin, Texas ("Artists in the American Desert")

University of Arizona Museum of Art, Tucson, Arizona ("Artists in the American Desert")

April, John Perreault, "Impressions of Arizona," *Art in America,* pp. 35–45.

May, *Israel Revisited* Exhibition Catalogue. Introduction by Harry Rand.

August 26–September 1, Francine Hardaway, "The Valley's Gift to the World," *New Times,* p. 27.

September, Harry Rand, "Some Notes on the Recent Work of Beth Ames Swartz," *Arts Magazine,* pp. 92–96.

October, "Review," *Art World,* p. 5.

October 13, John Perreault, "Just Deserts," *Soho Weekly News,* p. 49.

November/December, Carol Kotrozo, "Review," *Art Express Magazine,* pp. 52–53.

Fall, Pam Hait, "Women & Art; A Retrospective," *National Forum,* p. 16.

Fall/Winter, Mary Lou Reed, "A Vital Connection: Artist and Topography," *Woman's Art Journal,* pp. 42–45.

November/December, "Gallery," *Art Express,* pp. 52–53.

December, Mary Lou Reed, *Beth Ames Swartz' Stylistic Development, 1960–1980* (Thesis), Arizona State University, Tempe.

1982 Larger format work requires more studio space; January, starts building new studio; finishes in June.

Begins *Colly's Dream Series.*

May, Supreme Court Justice, Sandra Day O'Connor, buys a *Deborah* work for her Washington, D.C. office.

June, July, September, pilgrimages to Moon Rock; begins conception of "Moving Point of Balance."

Begins class dealing with Shamanism and Art.

Two works commissioned by Phelps-Dodge Corporation for their Phoenix, Arizona office.

Listed in *International Catalogue of Contemporary Art,* n.p.

Exhibits:

Arapaho College, Littleton, Colorado ("Artists in the American Desert")

Beaumont Art Museum, Beaumont, Texas ("Artists in the American Desert")

Broadmoor Community Church, Colorado Springs, Colorado ("A Way of Peace")

Centre de Arte, Jalisico, Mexico

Coconino Center for the Arts, Flagstaff, Arizona (solo)

Elaine Horwitch Galleries, Scottsdale and Sedona, Arizona (solo)

Frank Marino Gallery, New York, New York ("Paper Caper")

Hebrew Union College Skirball Museum, Los Angeles, California (solo: "Israel Revisited")

J. Rosenthal Gallery, Chicago, Illinois (solo)

Judah Magnes Museum, Berkeley, California (solo: "Israel Revisited")

National Women's Caucus for Art, New York, New York (sponsor, "Nature as Metaphor")

Palm Springs Desert Museum, Palm Springs, California ("Artists in the American Desert")

Print Making Council of New Jersey (sponsor, touring invitational exhibit, "Paper: Surface and Image")

Scottsdale Center for the Arts, Scottsdale, Arizona

Sun Valley Center Gallery, Sun Valley, Idaho (solo: "Fire/Earth Paintings")

University of Arizona Museum of Art, Tucson, Arizona (solo: "Israel Revisited")

University of California, Irvine, California (solo: "Israel Revisited")

February, Sarah Cecil, "New York Reviews," *ARTnews,* p. 174.

February 13, D. S. Rubin, "In Search of the Shekinah," *Artweek,* p. 31.

May 15, Fitzgerald Whitney, "Feminine Spirituality in Judaism," *Los Angeles Times,* Part II, p. 5.

Summer, Lynn Rigberg, "Beth Ames Swartz at Elaine Horwitch Galleries, Scottsdale," *Artspace Magazine,* p. 73.

July/August, Shelley Krapes, "A Painter's Way with Paper," *Fiberarts,* pp. 19–20.

1983 January, continues study of Shamanism, Shamanic healing, approaches art as a healing process.

Attends eight-day, experiential workshop; "Shamanic Healing, Journeying and the Afterlife," Esalen Institute, Big Sur, California, directed by Michael Harner, author of *The Way of the Shaman.*

Returns to working on canvas.

Reads Freda Kahlo's biography.

June 17–27, member of the "Southwest Pilgrimage, 1983," sponsored by Four Winds Circle, with main guide, John Kimmey and Hopi elder Preston Monongye; the group visited seven ancient, sacred Indian sites in the Southwest, performing rituals at each site.

Experiences a sense of finding a "spiritual" family—people with similar philosophical concerns.

July, travels to France, revisits museums previously visited in 1956, as well as many others. As in 1956, appreciates the beauty of the art. Visits

megaliths, Carnac, Brittany coast with artists Linda and John Farnsworth.

Views the 14,000-year-old cave paintings at Grotte de Font de Gaume at Les Eyzies de Tayac (Dordogne). Excited by the great stretch of art history.

Exhibits:

Albuquerque Museum of Art, Albuquerque, New Mexico (solo: "Israel Revisited")

Art Resources Gallery, Denver, Colorado (solo)

Beaumont Art Museum, Beaumont, Texas (solo: "Israel Revisited")

Brentwood Gallery, St. Louis, Missouri (Invitational: "The Southwest Scene")

California State University, Los Angeles, California (Invitational: "Exchange of Sources, Expanding Powers")

Deicas Art, La Jolla, California (solo)

DuBose Gallery, Houstin, Texas

Elaine Horwitch Galleries, Santa Fe, New Mexico (solo: "A Moving Point of Balance")

Eve Mannes Gallery, Atlanta, Georgia (Invitational: "Handmade Paper")

National Museum of American Art, Smithsonian Institution, Washington, D.C. (Granite Gallery, "Selected Works on Paper," Works on Paper from the Permanent Collection)

Sangre de Cristo Art Center, Denver, Colorado ("Artists of the Rockies and the Golden West Retrospective")

Tempe Fine Arts Center, Tempe, Arizona ("Women in Art")

University of Tennessee, Knoxville, Tennessee ("Exchange of Sources, Expanding Powers")

Commissioned work for Madison Green, New York, New York.

Bethlehem #2, bought by Joy Anderson for the Betty Ford Center of the Eisenhower Medical Center, Rancho Mirage, California.

March 19, Sheila ffolliott, "Expanding Powers," *Artweek,* p. 6.

April 4, Alice Durnford, "Works Capture Spirit of Jewish Women," *Beaumont Journal,* Beaumont, Texas, p. 6a.

Spring, Lucy Lippard, *Overlay: Contemporary Art and the Art of Pre-History,* Pantheon Books, pp. 266–67.

July 22, Max Price, "Colliding Forces Work to Create Excitement," *Denver Post,* n.p.

Summer, Donald Locke, "Beth Ames Swartz at Elaine Horwitch Galleries, Santa Fe," *Artspace,* p. 76.

October, Anna Katherine, "Exploration of Elemental Forces; Beth Ames Swartz," *ARTlines,* pp. 16–17.

November, Carol Donnell-Kotrozo, "Beth Ames Swartz; Elaine Horwitch Galleries," *Artforum,* pp. 84–85.

1984 Begins "A Moving Point of Balance," for Nickle Arts Museum, Calgary, Alberta, Canada, curated by Karyn Elizabeth Allen, to tour, 1985–1987.

Exhibits:

Cheney Cowles Memorial Museum, Spokane, Washington

DuBose Gallery, Houston, Texas (solo)

Elaine Horwitch Galleries, Scottsdale, Arizona (solo: "Selected Works, 1970–1984")

Senior Eye Gallery, Long Beach, California

SELECTED CORPORATE COLLECTIONS

American Republic Insurance Company, Des Moines, Iowa
Arizona Bank, Phoenix, Arizona
Central Bank of Colorado, Denver, Colorado
Empire Savings and Loan, Denver, Colorado
Home Petroleum, Denver, Colorado
Houston Oil and Minerals, Denver, Colorado
IBM Corporation, Endicott, New York
Madison Greene, New York, New York
Midlands Federal Savings Bank, Denver, Colorado
Mountain Bell Telephone Company, Denver, Colorado
National Bank of Arizona, Scottsdale, Arizona
Petro Lewis Corporation, Denver, Colorado
Phelps Dodge Corporation, Phoenix, Arizona
Prudential Life Insurance Company, Newark, New Jersey
Subaru Corporation, Denver, Colorado
United Bank, Denver, Colorado
Valley National Bank, Phoenix, Arizona
Western Savings and Loan, Phoenix, Arizona
William Feldman & Associates, Los Angeles, California

MUSEUM COLLECTIONS

Albuquerque Museum of Art, Albuquerque, New Mexico
Arizona State University, Matthews Center Collection,
 Tempe, Arizona
Beaumont Art Museum, Beaumont Texas
Brooklyn Museum, New York
Denver Art Museum, Denver, Colorado
Everson Museum of Art, Syracuse, New York
Herbert F. Johnson Museum of Art, Cornell University,
 New York
The Jewish Museum of New York
Museum of Fine Arts, Santa Fe, New Mexico
National Museum of American Art, Smithsonian Institution,
 Washington, D.C.
Phoenix Art Museum, Phoenix, Arizona
San Francisco Museum of Modern Art,
 San Francisco, California
Scottsdale Center for the Arts, Scottsdale, Arizona
Tucson Museum of Art, Tucson, Arizona
University of Arizona Museum of Art, Tucson, Arizona
Yuma Art Center, Yuma, Arizona

BIBLIOGRAPHY

Christ, Carol P. *Diving Deep and Surfacing.* Boston: Beacon Press, 1980.

———— and Judith Plaskow, editors. *Womanspirit Rising.* New York: Harper & Row, 1978.

Chung-Yuan, Chang. *Creativity and Taoism: A Study of Chinese Philosophy, Art and Poetry.* New York: Harper & Row, 1970.

Coomaraswamy, Ananda K. "Art and Craftsmanship," in *Reflections on Art,* edited by Susanne M. Langer. New York: Oxford University Press, 1968.

Gettings, Fred. *Dictionary of Occult, Hermetic and Alchemical Sigils.* Boston: Routledge & Kegan Paul Ltd., 1981.

Gonzalez-Wippler, Migene. *A Kabbalah for the Modern World.* New York: Bantam Books, Inc., 1977.

Gowig, Laurence. *Turner: Imagination and Reality.* New York: Museum of Modern Art, 1966.

Grohmann, Will, editor. *Paul Klee.* New York: Harry N. Abrams, Inc., 1967.

Halevi, Z'ev ben Shimon. *Kabbalah: Tradition of Hidden Knowledge.* New York: Thames and Hudson, 1979.

Hall, Manly P. *The Secret Teachings of the Ages.* Los Angeles, CA: The Philosophical Research Society, Inc., 1978.

Harner, Michael. *The Way of the Shaman.* New York: Bantam Books, 1982.

Hess, Thomas B. and John Asbery, editors. *Art of the Grand Eccentrics.* New York: Macmillan, 1971.

Jaffe, Amelia. *The Myth of Meaning.* Englewood Cliffs, NJ: Prentice-Hall, 1979.

Janeway, Elizabeth. *Between Myth and Morning: Women Awakening.* New York: William Morrow & Co., 1975.

Jung, C. G. *Memories, Dreams, Reflections.* New York: Vintage Books, 1963.

Kelley, Earl C. and Marie I. Rasey. *Education and the Nature of Man.* New York: Harper & Row, 1952.

Kubie, Lawrence. *Neurotic Distortion of the Creative Process.* New York: Farrar, Strauss & Giroux, 1961.

Kübler-Ross, Elisabeth and M. Warshaw. *To Live Until We Say Good-by.* Englewood Cliffs, NJ: Prentice-Hall, 1978.

Land, George T. L. *Grow or Die/The Unifying Principle of Transformation.* New York: Dell Publishing Co., 1973.

Lippard, Lucy R. *Overlay/Contemporary Art and the Art of Prehistory.* New York: Pantheon Books, 1983.

Progoff, Ira. *Jung, Synchronicity, and Human Destiny, Non-Causal Dimensions of Human Expression.* New York: Crown, 1973.

Purce, Jill. *The Mystic Spiral, Journey of a Soul.* New York: Thames and Hudson, 1980.

Ruther, Rosemary Radford. "Motherearth and the Mega Machine: A Theology of Liberalism in a Feminine, Somatic and Ecological Perspective," in *Womanspirit Rising,* Carol P. Christ and Judith Plaskow, editors. New York: Harper & Row, 1978.

Scholem, Gershom. *On the Kabbalah and its Symbolism.* New York: Schocken Books, 1965.

Schwartz, Frances Wilson. "Human Nature and Aesthetic Growth," in *Self-Explorations in Personal Growth,* edited by Clark E. Moustakas. New York: Harper & Row, 1956.

Schwenk, Theodor. *Sensitive Chaos: The Creation of Flowing Forms in Water and Air.* New York: Harper & Row, 1976.

Sinnott, Edmund W. *Self and Psyche, the Biology of the Spirit.* New York: Viking Press, 1955.

Steinhaltz, Adin. *The Thirteen Petalled Rose.* New York: Basic Books, 1980.

Stronbert, Gustaf. *The Soul of the Universe.* New York: David McKay, 1940.

Suares, Carlo. *The Sepher Yetsira.* Boulder, CO: Shambala, 1976.

Swindler, Leonard. *Biblical Affirmations of Women.* Philadelphia, PA: The Westminster Press, 1979.

Tillich, Paul. *The Courage to Be.* New Haven, CT: Yale University Press, 1952.

Wickes, Frances G. *The Inner World of Choice.* Englewood Cliffs, NJ: Prentice-Hall, 1976.

JOURNALS AND CATALOGS

Greer, Germaine. "The Repression of Women Artists." *Atlantic Monthly,* September, 1979.

Marin, John. Centennial Exhibition, Los Angeles Museum of Art, 1970 Catalog.

O'Connor, Frances V. "Pollock, New Discoveries of Early Work." *Horizon,* January/Feburary, 1979.

Yankelovitch, Daniel. "New Rules in American Life: Searching for Self-Fulfillment in a World Turned Upside Down." *Psychology Today,* April, 1981.

ART INDEX

DESIGNED BY DAVID JENNEY
COMPOSED IN PHOTOTYPE OPTIMA
WITH DISPLAY IN AVANT GARDE GOTHIC
PRINTED ON SHASTA GLOSS
AT THE PRESS IN THE PINES

NORTHLAND PRESS